HOW TO
DRAW
PETS

A STEP-BY-STEP GUIDE

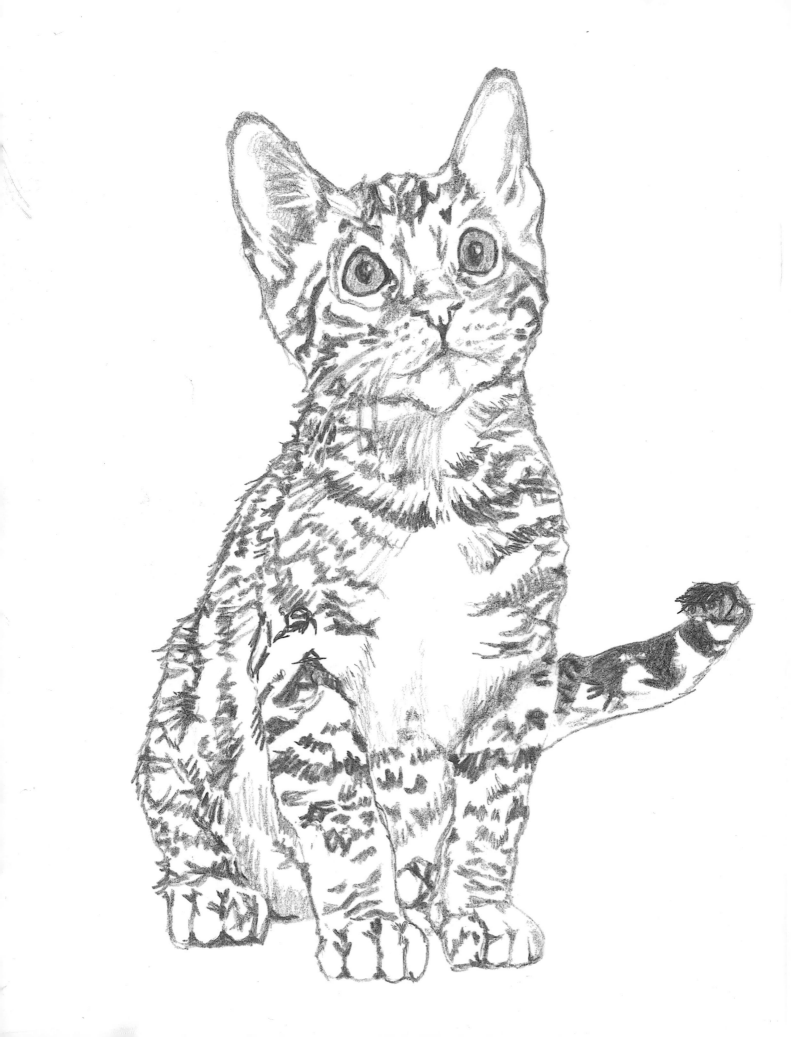

HOW TO
DRAW
PETS

A STEP-BY-STEP GUIDE

Aimee Willsher

ARCTURUS

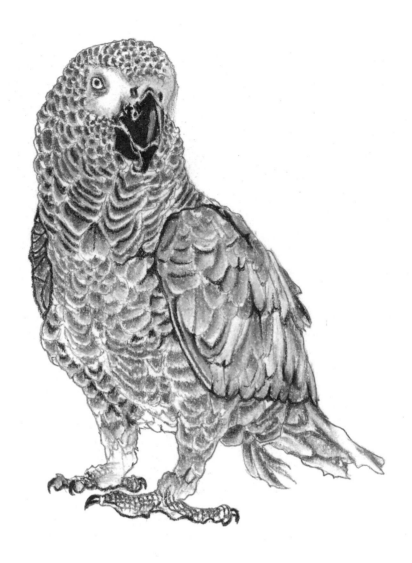

ARCTURUS

This edition published in 2014 by Arcturus Publishing Limited
26/27 Bickels Yard, 151–153 Bermondsey Street,
London SE1 3HA

ISBN: 978-1-78212-626-3
AD003866UK

Printed in China

Contents

INTRODUCTION

All pet owners know the joy that animals can bring to our lives. They cheer us up when we're sad, keep us company when we're lonely and provide an endless source of fun. In fact, we love our pets almost as much as we love our friends and family!

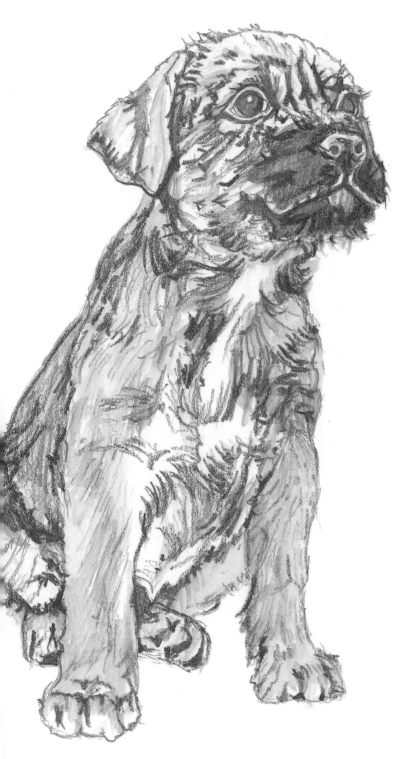

Pets are not only cute and interesting to look at – each animal has its own character and personality that its owner knows and understands. The close relationship that we have with our pets makes them a perfect subject for anyone who wants to start drawing, since not only are we visually familiar with their forms and the way they move, they are always around us as a source of inspiration for a new piece of art.

Starting to draw pets may seem like a daunting task. Translating the fidgety, mobile form of an animal into a static image that not only looks like your pet but also evokes its character may at first seem like an impossible achievement, but it really isn't. The key to drawing is not learning complicated techniques or buying lots of fancy materials – it's changing the way you see the world to allow you to make two-dimensional drawings appear to the eye as three-dimensional forms.

Whether you already have some experience of drawing or are an absolute beginner, this book will help you to create beautiful drawings of your pets and give you the confidence to develop your own individual style and experiment with new mediums. Even if you don't have a pet of your own and are simply an animal lover, it will open your eyes to the rich variety of animals that surround us on a day-to-day basis.

To do this you must look very carefully at your subjects, observing the direction of contours that make the form of the animal's body and the way in which light and shade interact on the surface. Combining accurate contour lines with shading will begin to overcome the conundrum of how to represent a solid three-dimensional form on a flat surface and your drawings will soon take on a convincingly life-like appearance.

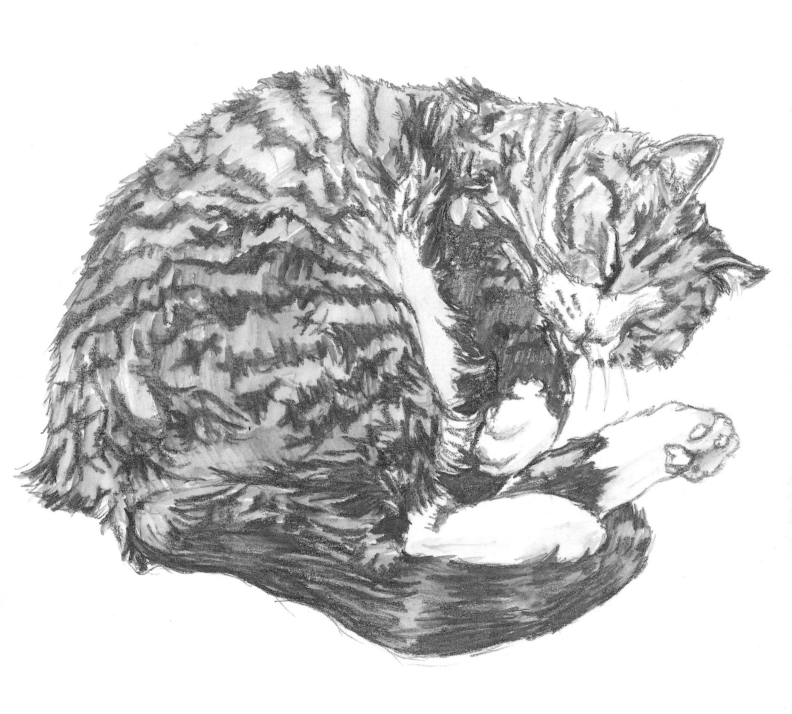

Getting started

If you're a novice artist, the range of materials available and the plethora of information in books and on websites may seem bewildering. The answer is to keep things simple, limiting yourself to a few materials and learning how to use them really well rather than coming home from an art shop laden with a lot of expensive equipment you may never use. As your expertise grows, you'll no doubt enjoy experimenting with different drawing tools and discovering which manufacturer's products you particularly like for the effects you want to create.

Materials

The first obvious tool is the trusty pencil, an item we're all familiar with. Because you will have used pencils since your earliest schooldays, you will be relaxed and confident about handling what might seem a humdrum drawing tool – but don't underestimate it, as some of the finest drawings have been produced with this medium. In Chapter 5, you'll find details of more materials to try as your skill develops.

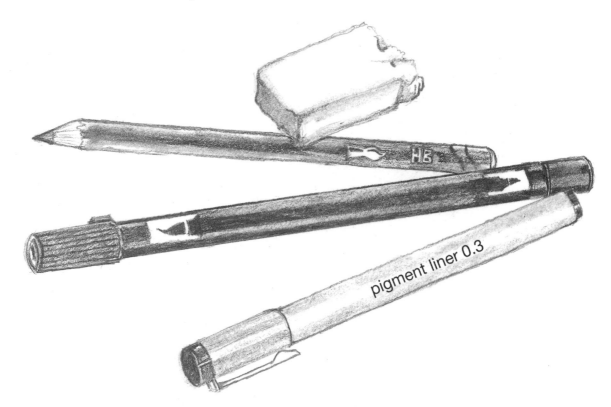

Pencils are available in a range of grades, from very hard to very soft leads. The hard grades are those from H to 9H, while B to 9B are soft, the highest number indicating the hardest or softest lead respectively. HB represents the middle grade. You'll need a range of pencils, the soft leads to produce dark, intense shade and hard leads for fine, precise lines and pale shaded tones. For the early stages of a drawing, a propelling pencil with an HB lead is ideal, as it will give you a line of unvarying width.

Watersoluble pencils are also available, offering the advantage that once you have shaded an area you can blend and gradate the tones with a damp brush. These pencils are a good way to start familiarizing yourself with handling a brush, which will help you to make the transition to painting. For erasing mistakes, use a putty rubber, which won't disturb the surface of the paper. To sharpen your pencils, a craft knife is better than a pencil sharpener as you can expose more lead for shading purposes.

Basic techniques

Making a realistic image is not only about drawing an accurate outline; you also need to create the illusion of three-dimensional forms on a flat piece of paper. This is done by shading the forms to establish textural and tonal variation, which will also add visual interest to your drawing. Here are a few key techniques to start experimenting with.

Before you tackle a particular subject, it's a good idea to practise making abstract marks on scrap paper to help you relax into the process of drawing. This doesn't only apply when you're a beginner; even established artists do this to free up their hand movement before starting work.

Hatching

In this classic technique, short lines following one direction are drawn. Varying the spacing between the lines lightens or darkens the tonality of the area, while curving them suggests rounded three-dimensional form.

Cross-hatching

This is a variation on hatching, as the name suggests. Once you have completed a series of lines going in one direction, add a secondary layer of lines at right angles to them. Cross-hatching is a good way of adding gradually darkening areas to a drawing. As with hatching, varying the spacing between the lines affects the depth of tone.

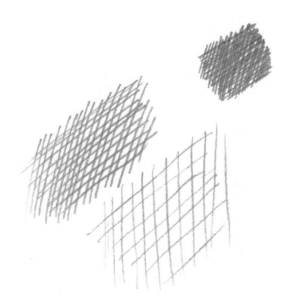

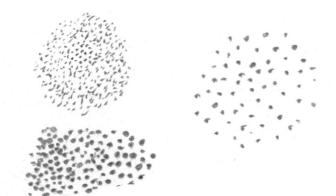

Stippling

The stippled effect is created by making numerous small dots on the surface of the paper so that en masse they create tonal and textural variation. As with hatching, closer spacing establishes darker tones.

Shading

Simple shading is achieved by rubbing the pencil on the paper, using light pressure for pale tones and heavier pressure where dark tone is needed. Texture can be achieved by loosening the shaded line into a rough scribble.

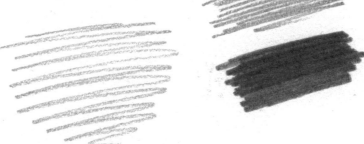

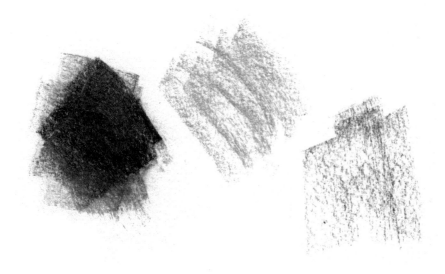

Scumbling

The art of scumbling is to layer tones in such a way that the undersurface shows through. This can be produced by lightly and softly shading the bare paper so that the colour of the paper remains partly visible beneath. You can also layer a light colour over a darker base, which is particularly effective when using soft pastels (see p 88).

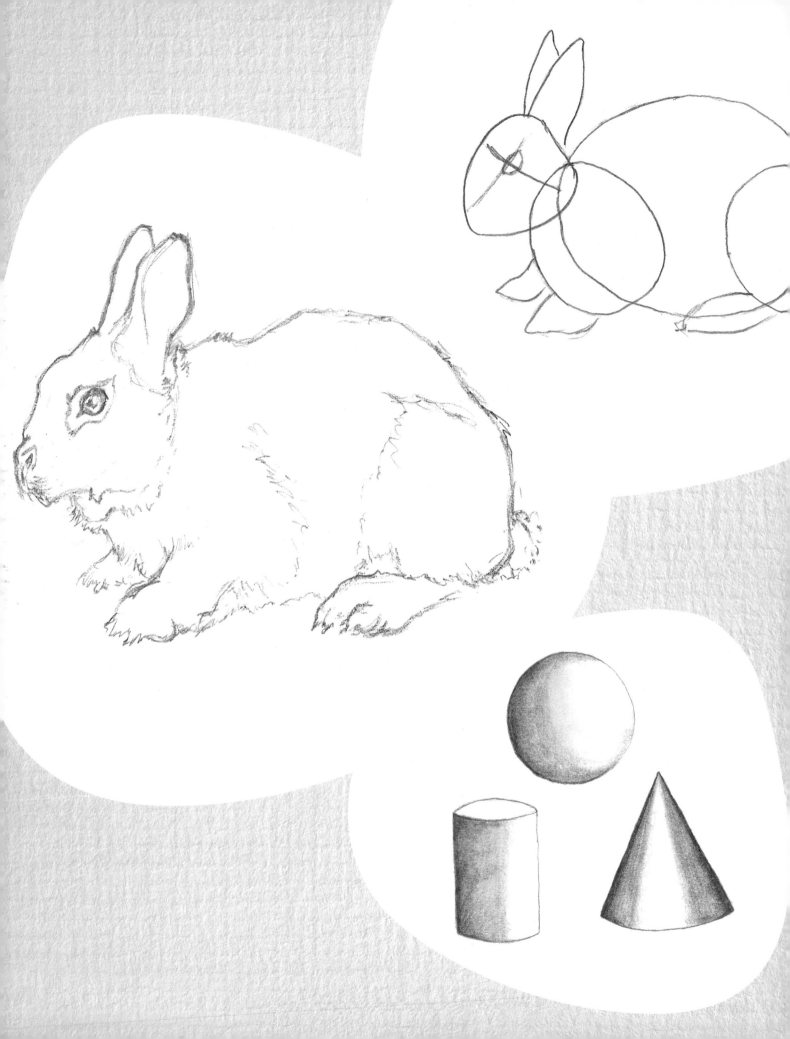

GETTING TO GRIPS WITH FORM

The variety to be found within the animal world is amazing, and even domestic pets come in all shapes and sizes. Yet any kind of animal, however complicated its form, can be simplified by using shapes with which we are all familiar in order to construct a primitive but accurate outline. This combination of primary shapes can then be refined to produce a realistic contour. With this method, you will see how starting to draw any animal can be easy.

We shall start with the basics of drawing simple forms to help you overcome the tentative process of beginning a new discipline. Once you are comfortable with creating lines to produce a simple shape, we shall look at how the three-dimensional form of the shape can be evoked by using strategically placed shading.

Simple shapes and the illusion of three dimensions

Although it's important not to get bogged down with formal processes and techniques that can restrict your creativity, it's helpful to start with the basics of primary shapes. Here are a few simple shapes created with a single contour line. They are very easy to copy, so have a go at drawing some of them freehand and with a ruler and compass.

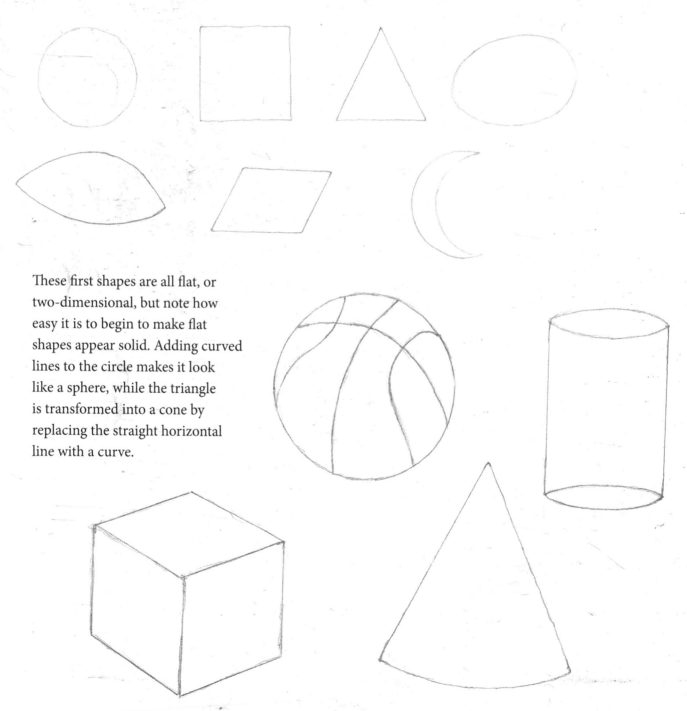

These first shapes are all flat, or two-dimensional, but note how easy it is to begin to make flat shapes appear solid. Adding curved lines to the circle makes it look like a sphere, while the triangle is transformed into a cone by replacing the straight horizontal line with a curve.

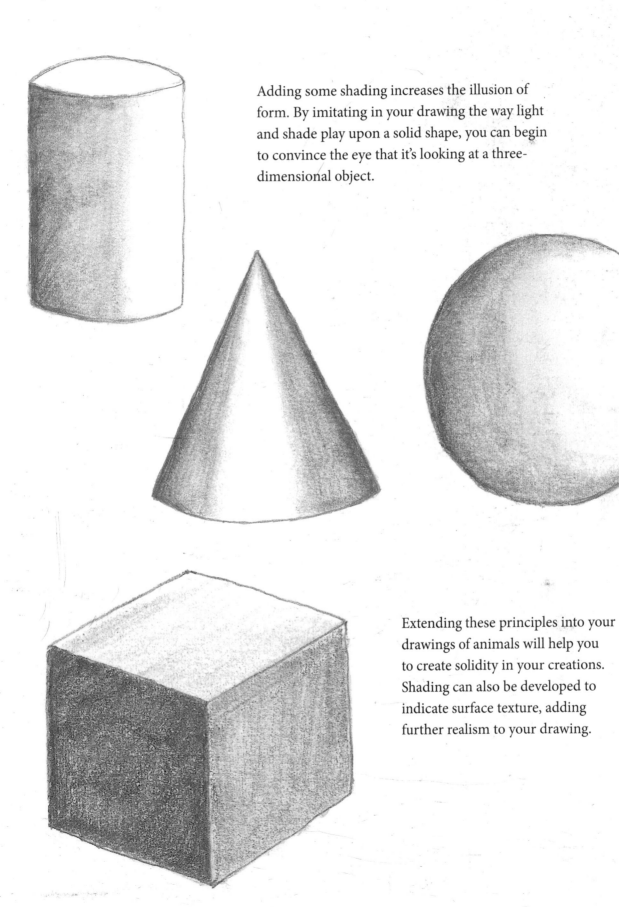

Adding some shading increases the illusion of form. By imitating in your drawing the way light and shade play upon a solid shape, you can begin to convince the eye that it's looking at a three-dimensional object.

Extending these principles into your drawings of animals will help you to create solidity in your creations. Shading can also be developed to indicate surface texture, adding further realism to your drawing.

Difference is only skin deep

It's important to be aware of the skeletal structure of an animal when you're starting to draw, since the bones are the foundation that creates the form of the body. Looking at the animal skeletons shown here, you'll see that apart from the tortoise, whose main protection is the exoskeleton of its distinctive shell, and the fish, the components of each animal's bone structure are pretty much the same. Just like humans, they all have a ribcage, spine, skull and limbs. The visual difference is produced by the relative proportions of each of these bone categories and how the bones are held in position with muscles and skin and finally covered with fur, feathers or scales.

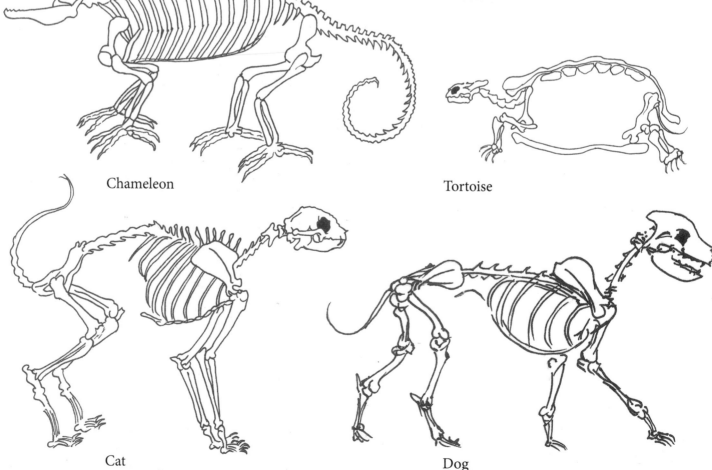

Rabbit

Chameleon

Tortoise

Cat

Dog

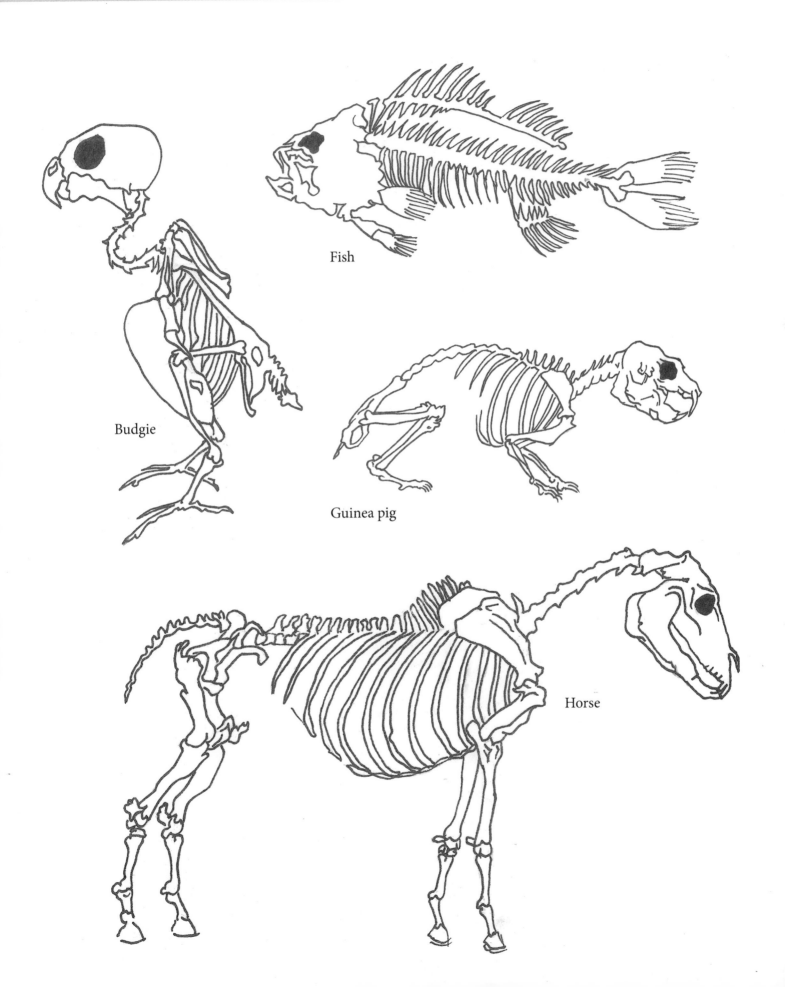

Fish

Budgie

Guinea pig

Horse

The dog, cat and horse

The body of a dog, cat and horse can be started using the same basic shapes. Begin with two circles to establish the chest and haunches and connect these with lines that form the belly and spine.

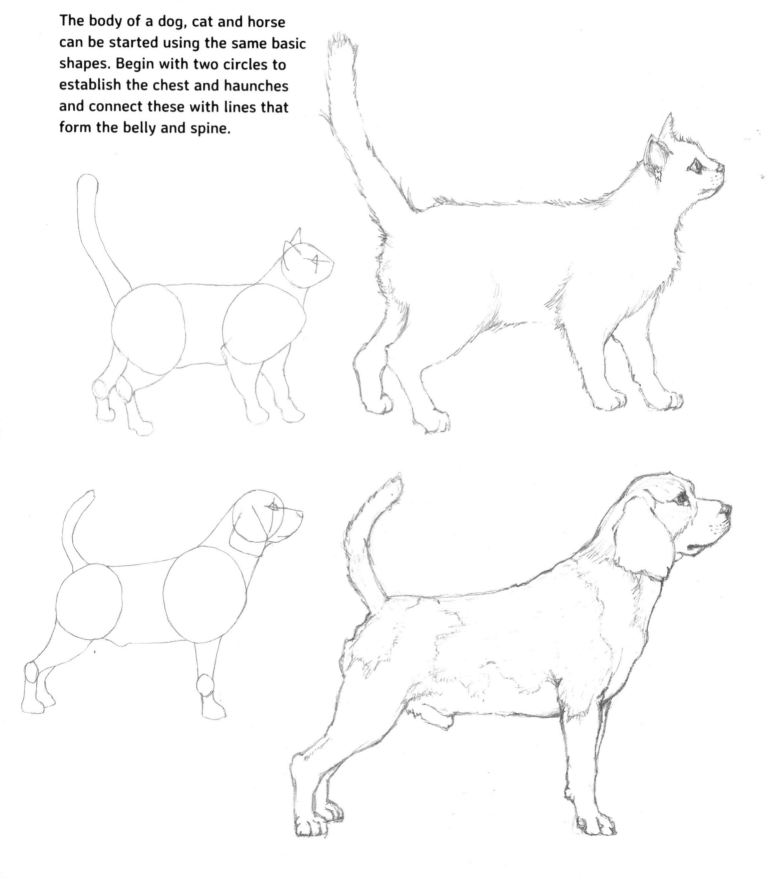

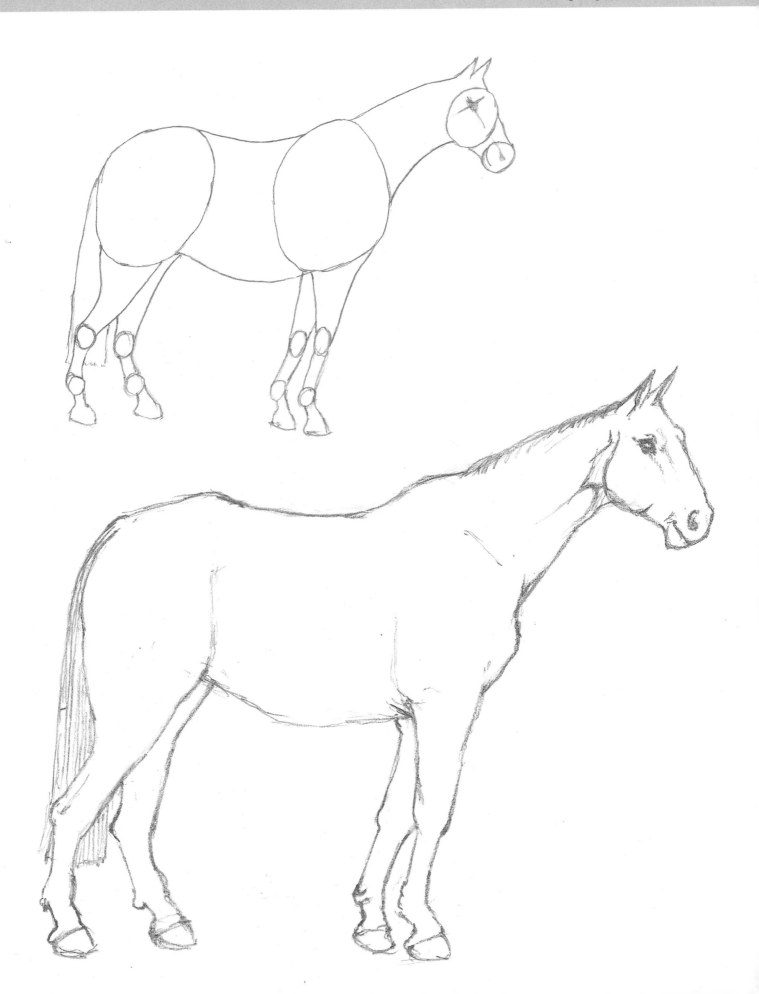

Smaller animals

As they tend to be easier to draw, small animals are less daunting to tackle, which makes them especially good subjects for you to start with. They have a relatively simple outline, small limbs and rounded forms.

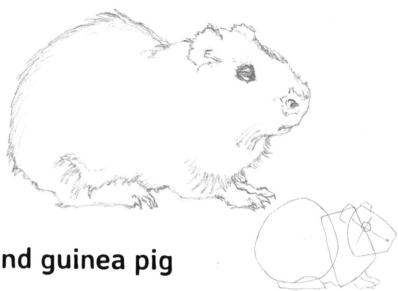

The rabbit and guinea pig

Rabbits and guinea pigs are both rodents, a group that also includes rats, mice, hamsters and chinchillas. Both drawings start with a large circle that forms the main bulk of the body.

The budgie

Start the budgie by constructing an oval shape drawn at an angle. The head, wings and tail shapes can then be added to this central form. This approach can be used when drawing any pet bird, from a parrot to the smallest cage bird.

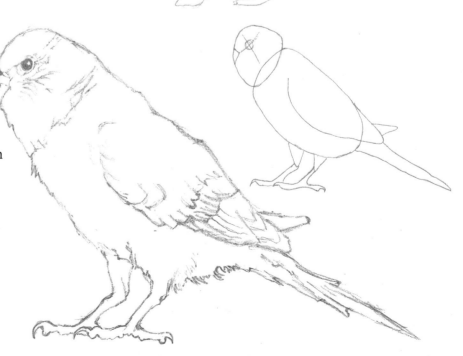

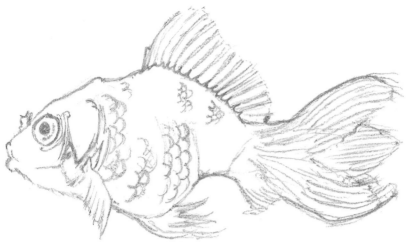

The goldfish

Draw a horizontal oval that tapers to a rounded point at each end, then add the tail and fin shapes.

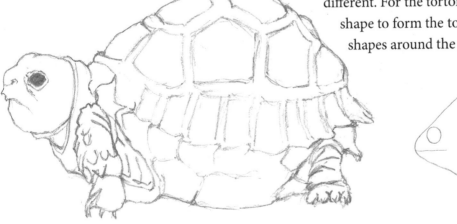

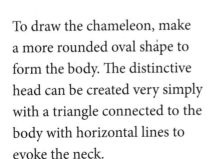

The tortoise and chameleon

Although these are both reptiles, they are structurally very different. For the tortoise, start with the tapered oval shape to form the top of the shell and build the other shapes around the centre.

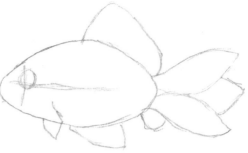

To draw the chameleon, make a more rounded oval shape to form the body. The distinctive head can be created very simply with a triangle connected to the body with horizontal lines to evoke the neck.

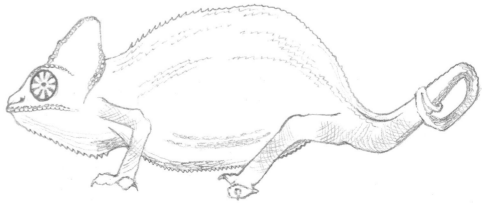

DRAWING DETAIL

Now that you have got to grips with how to use simple shapes to build the forms of different animals, it's time to incorporate refined detail within these forms so that you can really start to convey the individuality of a particular subject.

Making studies of details is very useful. Start to observe the ears, eyes, noses and feet of animals you see every day; how do they characterize a particular animal or breed? Practise sketching these details so that you can create real variety within your work. Once you are confident about how to capture the obvious differences between, say, a bulldog and a greyhound, you will start to progress further so that you can observe and convey the smaller variations that distinguish two dogs of the same breed.

Close observation and practice is well worth the effort. Injecting detail into your studies will really help you to make beautiful drawings of your treasured pets and show sensitivity to each animal's unique qualities.

Dog and cat eyes: step-by-step

The eyes of dogs and cats offer you a great way of conveying emotion and character in your pet drawings. A viewer always engages first with the eyes in an animal drawing, so it's important to get them right. While it may seem difficult to capture such an expressive feature, if you tackle the process using my step-by-step method you will find the eye an easy detail to master.

Both cat and dog eyes are made up of a pupil, an iris and upper, lower and third eyelids. The main distinction between them is the pupil: cats have vertical pointed-oval pupils, while those of dogs are more rounded.

Always observe where light is reflected upon the glassy surface of the eyeball. Leaving these reflective areas white will enhance the realism of the eye.

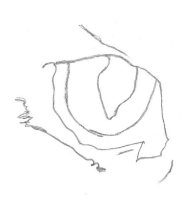

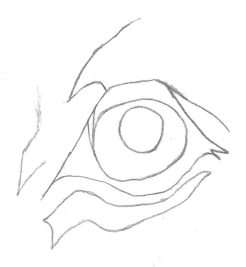

Step 1

Start with a simple linear drawing to describe the eyes. The outermost lines denote the upper and lower eyelids; these contain the circles that represent the irises. Within this circle is the pupil. Remember, this is where the real difference between the cat and dog eye is apparent – draw a vertical pointed oval for the cat and a circle for the dog. Add some lines around the outer eyelids that start to describe the setting of the eye.

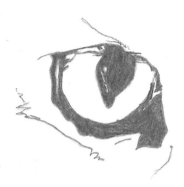

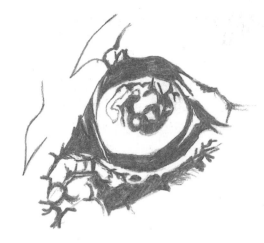

Step 2

Begin to shade in the darkest areas of the eyes. The pupil of every animal is effectively a hole that lets light through to the retina, from where visual information is transmitted to the brain by the optic nerve. It appears dark because all the light is absorbed by the retina, and you need to show this depth of tone in your drawing. After this, begin to shade the upper and lower eyelids.

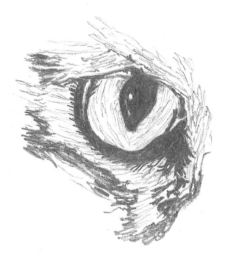

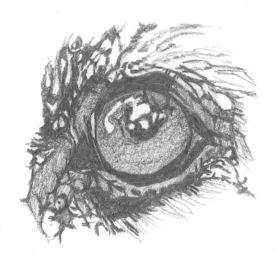

Step 3

In this last step, start to add detail to your drawing. This will begin to evoke the three-dimensional form of the eye and bring your drawing to life.

Other cat and dog features

Another important characteristic of all cats and dogs is the texture of their fur, whether it be long, short, uniform in colour or patterned with distinctive markings. Make some sketches such as I have done to practise describing patterned, smooth and fluffy fur.

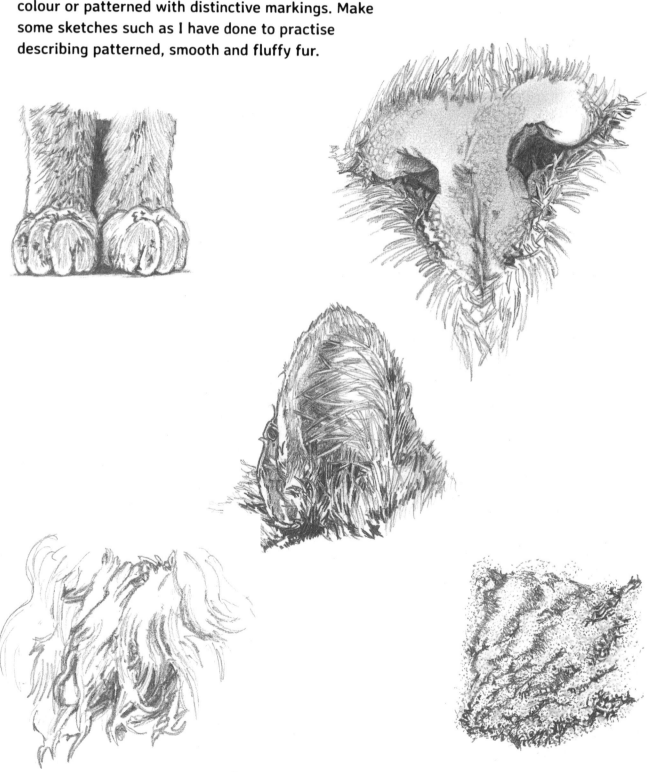

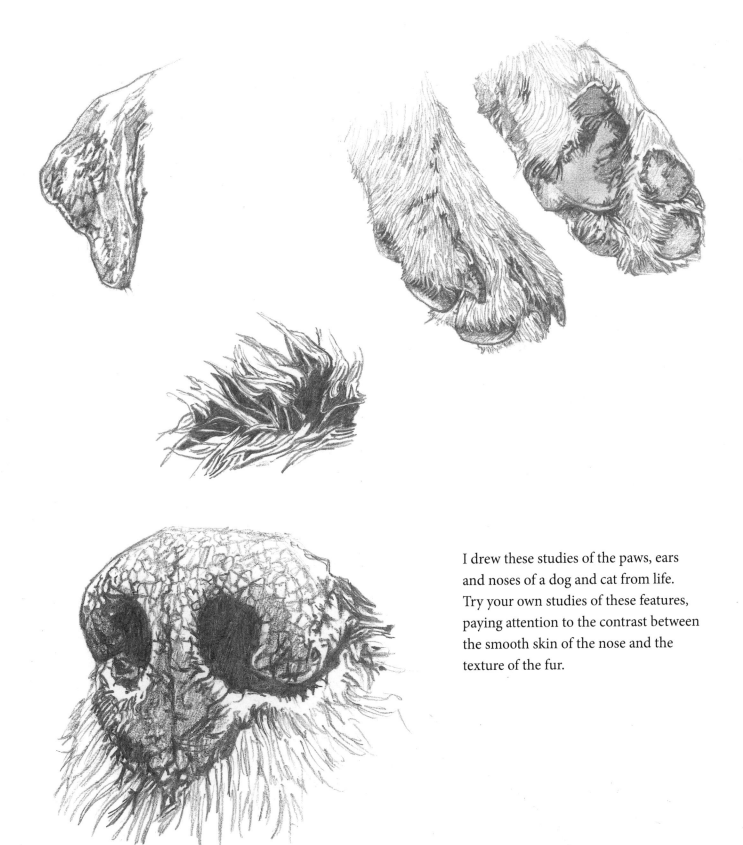

I drew these studies of the paws, ears and noses of a dog and cat from life. Try your own studies of these features, paying attention to the contrast between the smooth skin of the nose and the texture of the fur.

Dogs' heads

Dogs come in all shapes and sizes, so there's no end of variety to inspire us. I have focused on three studies of dogs' heads to show how different one breed can be from another. Here we have the long nose and smooth coat of the dachshund, the blunt nose and droopy jowls of the boxer and the distinctive curly fur and square head of the Irish terrier. Each head can be simplified by using primary shapes as a starting point.

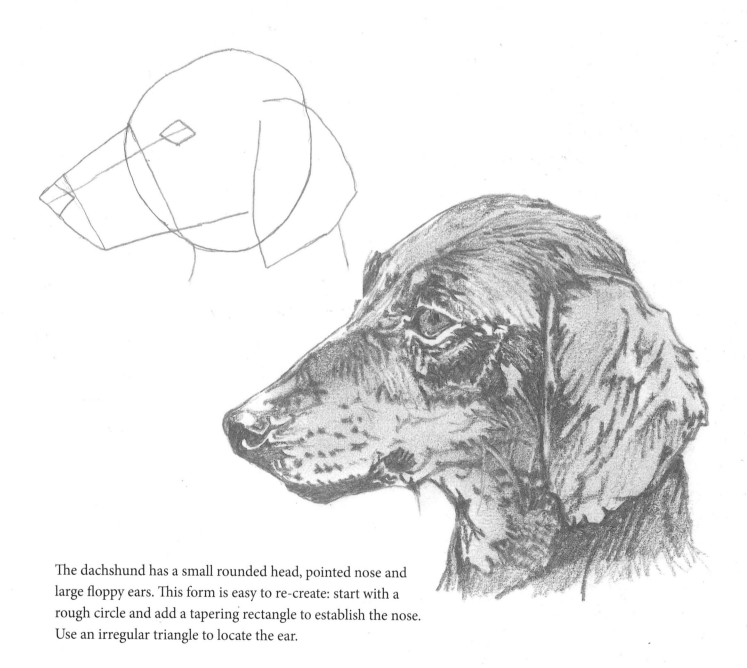

The dachshund has a small rounded head, pointed nose and large floppy ears. This form is easy to re-create: start with a rough circle and add a tapering rectangle to establish the nose. Use an irregular triangle to locate the ear.

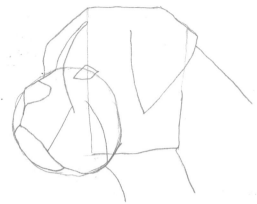

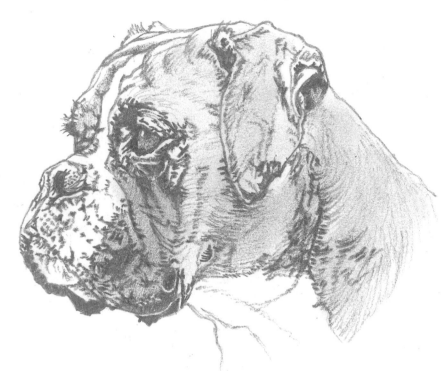

The boxer is very distinctive; it has a blunt, rounded muzzle and square head. Use a simple square to begin your drawing, then add a circle to the lower corner and a triangle to the upper opposite corner.

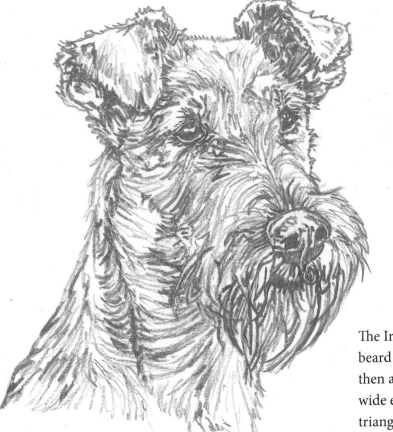

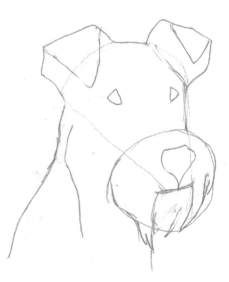

The Irish terrier is easily recognizable from its long beard and high-set ears. Start by drawing a cone shape, then add a circle to the tapered end of the cone. The wide end of the cone forms the top of the head. Use triangles to represent the folded ears.

Cats' heads

Cats don't have the same wide range of appearance as dogs; while their fur will vary in texture and length from breed to breed, their facial structure is very much the same. Here I have drawn the short-haired Siamese cat and the full, fluffy face of the Persian. Notice how the main bulk of the Persian's face can be drawn using a rugby ball shape and then divided centrally to locate the eyes and nose.

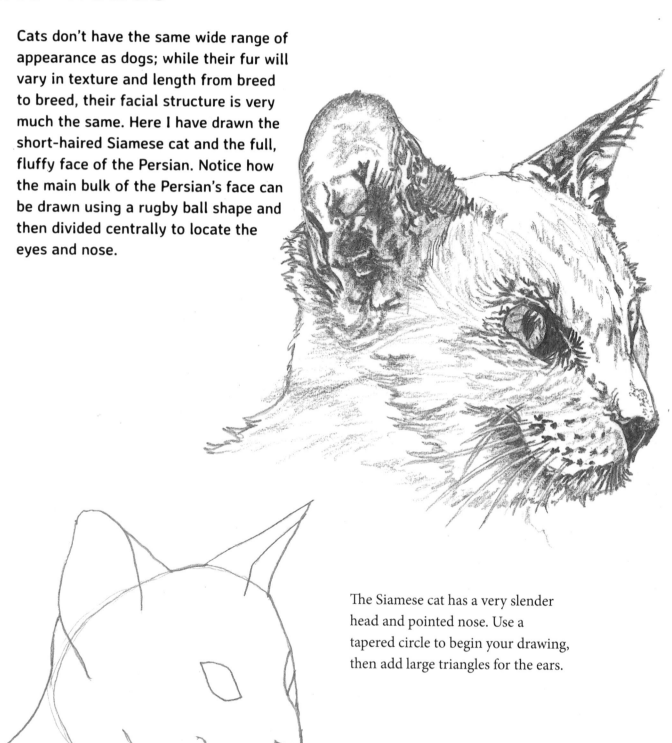

The Siamese cat has a very slender head and pointed nose. Use a tapered circle to begin your drawing, then add large triangles for the ears.

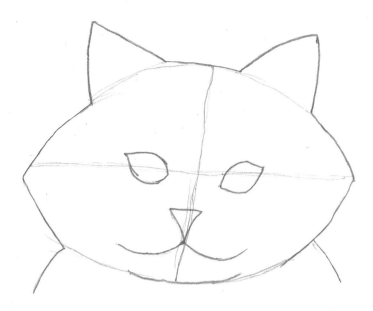

The Persian has a flatter, wider face, making a rugby ball the perfect shape with which to start your drawing. Add small regular triangles to the top to begin to describe the ears.

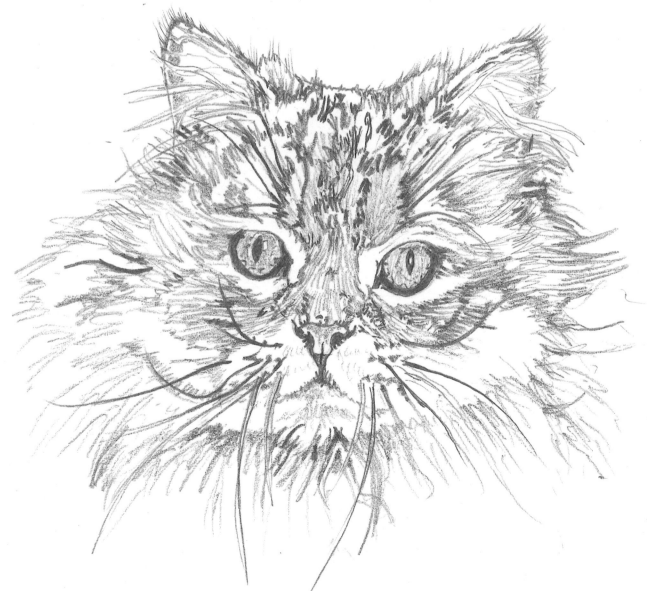

Rodents

A group of small prey animals, rodents have evolved to maximize their chances of escaping from potential predators. As a result they have eyes located on each side of their heads for good peripheral vision, quick reactions and speedy motor functions to enable them to flee when threatened.

Facial details

Rodents are characterized by the life-long growth of their front incisors, which are prevented from becoming too long by constant gnawing; any owner of a rodent knows that it's essential to provide things for their pets to chew. However, while they do have such similarities there is a great variation of appearance among the species. Here I have made studies of the nose, ears and eyes of a guinea-pig, a rabbit and a rat. Make your own studies from photographs and from life, concentrating on the features that make each species individual.

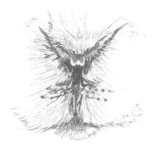
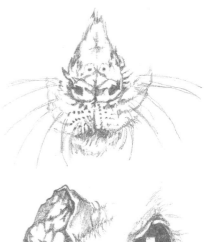
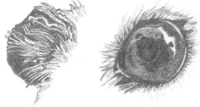
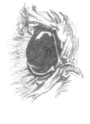
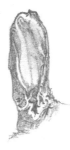

Guinea pig details

The guinea pig has a flat, snub nose, small hairless ears and large dark eyes located on either side of the head to give the animal a 340-degree field of vision. This feature is extremely valuable to small prey animals.

Rabbit details

The most distinctive feature of the rabbit is probably its long erect ears (although some domestic breeds are 'lop-eared'); these big ears are very useful for listening out for approaching danger. As in the guinea pig, the rabbit's eyes are located on the side of the head to enable wide peripheral vision.

Rat details

Rats have long, pointed noses and an excellent sense of smell. Unlike rabbits and guinea pigs, rats are omnivores and eat meat as well as vegetables – they are great scavengers and their good sense of smell helps them in this respect.

Rodent heads

Once you have become familiar with the details that make a particular rodent distinctive, you can begin to combine these facial features into detailed drawings of the entire head. When you are making your drawing, try to keep the feature that makes your subject distinctive in the forefront of your mind – such as the snub nose of the guinea pig, the long, pointed snout of the rat and the large eyes and erect ears of the rabbit. Focusing on characteristic features while you are drawing will help you to make your pet portrait recognizable.

Unlike cats and dogs, there is not much difference between rodents of the same breed, so try also to concentrate on distinctive markings to capture the essence of your pet.

Guinea pig head

You can see how the feature details have been combined and strategically located within the face to capture the spirit of the guinea pig. The lines describing the fluffy fur texture unite the features so that they work together in harmony, while the long whiskers positioned on each side of the nose help to accentuate the flatness of the snout.

Rat head

When making this drawing I used texture lines to describe the fur on the face of the rat. These lines also help to emphasize the tapering of the nose. I also included the front paws of the rat, holding some food up to its mouth, which adds an intensity of purpose to its expression.

Rabbit head

As I wanted to accentuate the rabbit's large, dark eyes I left a light perimeter around the eyeball, which helps to frame and mark the eye as the central focus of the face. I added dark fur markings to the sides of the face and the ears, as I felt that this helped to unify the facial features.

Birds

A good way to begin your exploration of birds is to make studies of stray feathers, since you can concentrate on those without risk of your model flying away. You might also find it easier to make studies of birds in action from photographs, which will allow you to capture a dynamic pose while giving you the time to make a detailed study of feathers and other features.

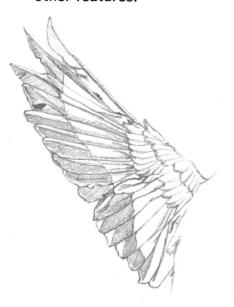

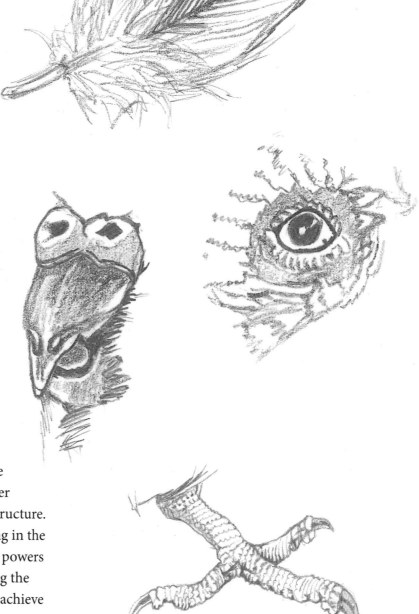

Here are some studies I made of the beak, eye, wing and claw of a budgie. Familiarizing yourself with the process of drawing these details will help you when you are drawing the whole bird. The outstretched wing shows the geometric pattern of the feathers making up its structure. Look at the study of the single feather and see how it has evolved to suit its purpose. The fine fibres stem from the central quill of the feather and are joined together to form an air-resistant structure. When all the feathers are adjacent and overlapping in the wing, they form an aerodynamic structure which powers the bird into the air. Understanding and mastering the formation of this structure will really help you to achieve realism in your bird drawings.

Reptiles and fish

These cold-blooded species are covered in scales, which help to protect their skin. While reptiles come in all shapes and sizes, domestic varieties are normally quite small. As aquatic creatures, fish have fins instead of legs and streamlined bodies to enable them to glide smoothly through the water.

Both fish and reptiles have distinctive scale patterns, and these can translate beautifully into a drawing. Their patterns are almost mathematical in their regularity.

The clown fish and gecko have bold, distinctive markings that are very satisfying to draw. Many reptiles and tropical fish have beautiful colouring, the markings sometimes distinguishing male from female. This is important to note if you are drawing a pair, one of each gender.

The chameleon eye and lizard claw demonstrate the same regular scale pattern.

In this study of fish scales, I mapped out their pattern by using interlacing diagonal lines. The small units formed by these lines were then rounded off into scale shapes.

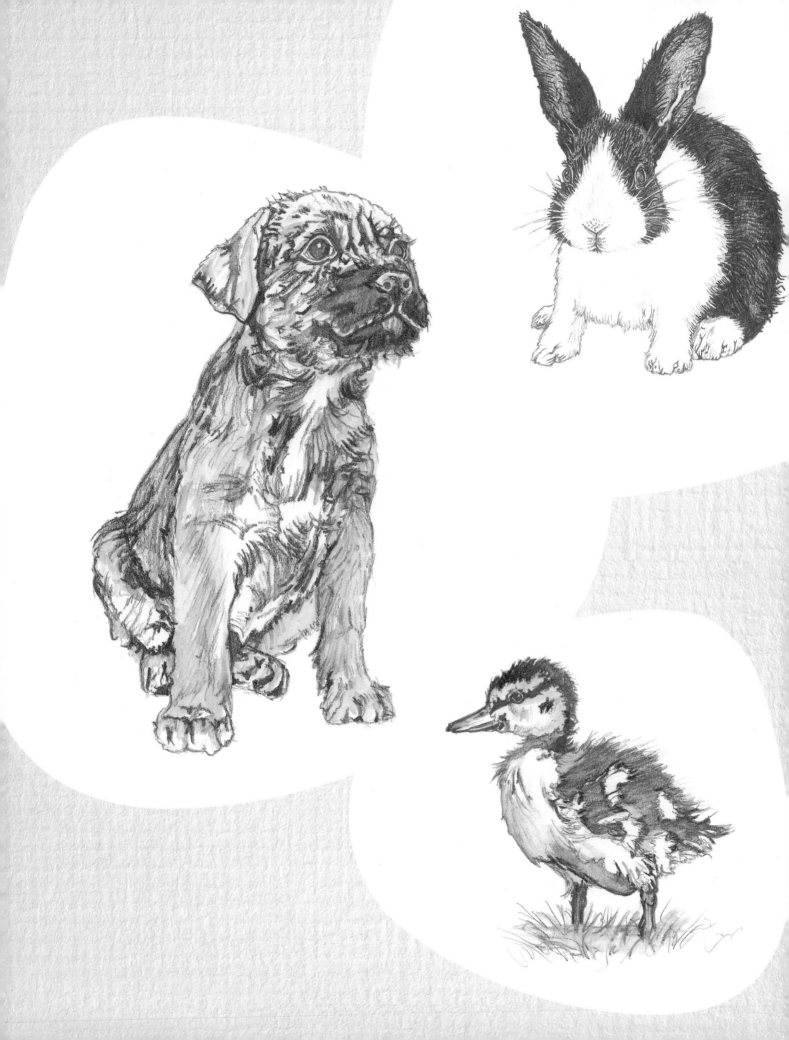

DRAWING FROM LIFE AND FROM PHOTOGRAPHS

In this chapter we shall explore approaches to drawing a range of animals, both from life and by using photographs as reference. While you may find this a bit daunting at first, there are techniques and tips to make starting out seem a lot easier.

Your own pets are fantastic subjects to concentrate on when beginning your endeavours into drawing from life; I shall explain how to use your sketchbook and develop rough preparatory drawings into more sophisticated finished works. Photographs are very useful to work from when you are starting to draw a particular animal or if you want to create a really detailed study, so you will discover here how to use the squaring-up method, which will ensure correct translations of size and proportion from photograph to paper.

Start sketching

Sketching from life is probably the most invigorating and exciting approach to creating a drawing. While it can be daunting and difficult when starting out, the process is rewarding and time spent upon it is more than worth while. Sketchbooks are available in various sizes, and it's a good idea to have an A5 one that you can put in your pocket for going out and about as well as an A4 size or more for larger sketches.

To perfect your sketches you need practice, and lots of it! However, just as important is training your mind to observe forms so that the lines that make up an animal's contour become firmly ingrained in your memory. Accurate observation and swift recording of what you see are the challenges. Keep your mind focused on the drawing, translating what you observe onto the page in front of you. Take care to draw what your eyes tell you and not what you think the animal *should* look like – a common error.

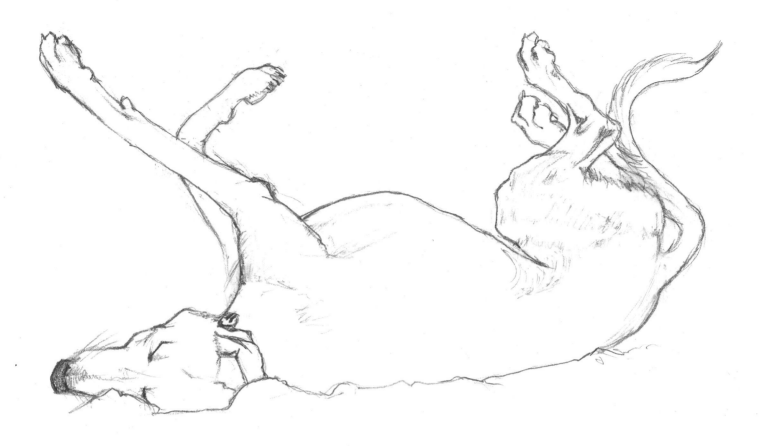

Your own pets can provide endless inspiration when you're starting to sketch from life. They are always available and you will know them well enough to be able to capture them motionless, even if it takes bribery with titbits. A sleeping pet is ideal when you're a beginner; if the animal is really tired it could stay in the same position for over an hour, leaving you plenty of time to work on your drawing. As your confidence grows and your sketching speed increases you'll be able to tackle more transient poses and more fidgety animals. These drawings are of my own pet dogs, Lily and Gracie the border terriers and Yvie the whippet.

How to use your sketchbook

A simple approach is best in your sketchbook – don't worry about style or whether you're getting every mark just right. Work rapidly without pausing to erase lines that you think are wrong, since your pencil needs to be in contact with the paper constantly so that you can build the form of the pose before the animal moves.

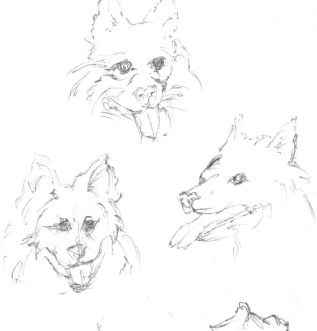

It's very important to the learning process to keep every sketch you make, even the unfinished ones; this means that you can come back to your sketches later to see how you have progressed, recognizing where a particular approach has worked and how you can build upon these fortunate accidents of line. Sketching is not only about capturing absolute visual perfection but also about evoking the character and essence of the animal you are trying to draw.

These sketches were made on a visit to a park, which is usually a great place to sit and look for an interesting animal to draw, especially different breeds of dog. I limited myself to 30 seconds per sketch and worked by looking and drawing at the same time, committing the pose to memory. This meant that once I had got the basic structure of the animal laid in on the page I could finish the sketch by calling upon the image as I remembered it. It's helpful to sketch the same animal in lots of different positions as this really impresses the three-dimensional form in your memory.

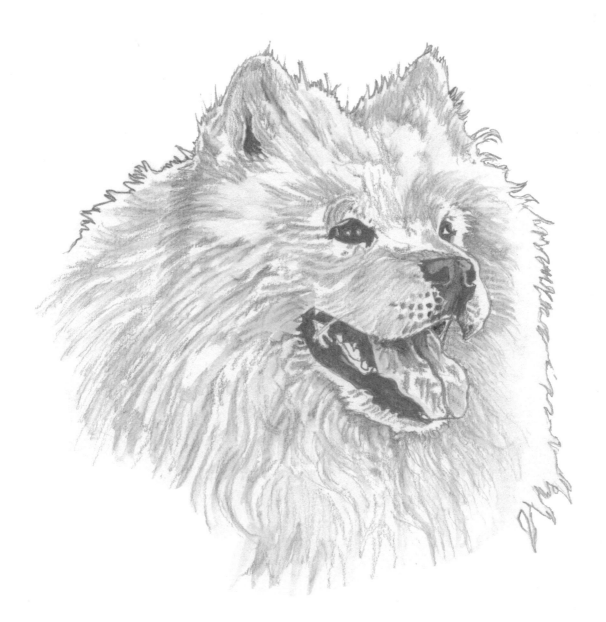

Your sketchbook should become a sort of *aide-mémoire* or visual dictionary that you can refer to whenever you need inspiration or you're having trouble remembering how to capture a certain animal form. I advise never starting on an image which you intend to work up into a finished piece without first having made numerous drawings of the animal in your sketchbook, as that way you have solid visual reference and also the advantage of experience in placing lines and contours to evoke your subject. I used my sketches of the samoyed's head (opposite) as reference to complete this finished watercolour portrait of the dog.

Drawing a dog from life

Dogs are one of my favourite animal subjects and there's nothing cuter than a puppy. I spent the morning with this border terrier pup, Charlie, only four months old at the time and a less than co-operative subject. Nevertheless, an artist shouldn't be deterred from drawing a wriggly animal.

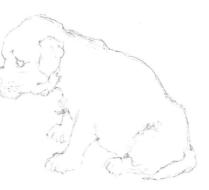

I started by making a series of very quick linear sketches, just focusing on his shape. I concentrated on the contour lines that describe his form and didn't worry about shading to suggest his three-dimensionality or fur texture as these are things that can be added later from memory. Each sketch took only a couple of minutes, just time enough for my subject to remain in one position.

One of the last sketches I made was of Charlie in a sitting position; it shows off his round puppy face and cuddly form. I decided this would be a great pose to develop into a finished study.

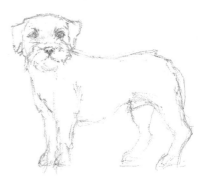

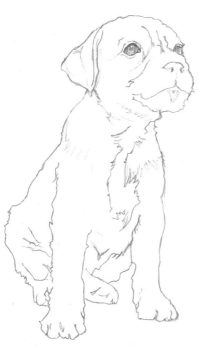

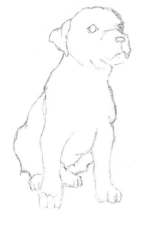

Materials and tools
HB propelling pencil
8B dark wash watersoluble
 pencil
Round watercolour brush,
 size 1
Eraser
Sketchbook
130gsm (60lb) smooth
 cartridge paper

Step 1

I copied this initial preparatory sketch using an HB propelling pencil, readjusting lines that I felt needed altering and using the surer confidence of line that comes with drawing something familiar. I also added lines to suggest his fur texture and position of markings. These were put in after Charlie had moved from his pose, but it's easy enough to do this just by having the puppy in front of you, even if he's jumping around.

Step 2

Using the watersoluble pencil, I began to block in areas of shading. Charlie's muzzle was almost black and his back and shoulders were very dark. I established these dark areas first, then added short, sketchy lines to suggest his fur texture. I also darkened his eyes, making sure to leave a little highlight, which always makes the expression of any animal come to life.

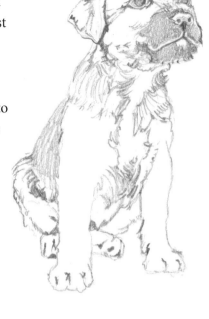

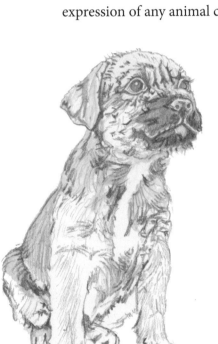

Step 3

Using the watercolour paintbrush dipped in clean water, I gently began to blend the shading.

Step 4

I continued to look at Charlie playing around in front of me and was able to observe and record how the direction of his fur described the solid form of his body. I added a few little finishing touches to my drawing, darkening areas here and there, adding a little more fur texture. I then added a final light wash to blend and soften these final details.

The most encouraging thing to learn about making a drawing from life is that not all the work and detail has to be completed with the subject in one position. As long as you have recorded the basic linear outline of the animal in the pose you want to create, the rest can be added by observing details over a longer period of time when the animal may be playing or at rest in a slightly different position.

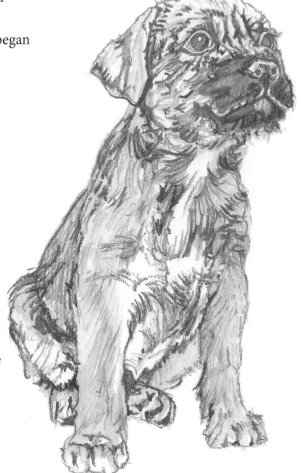

Drawing a cat from life

A somnolent cat is a fantastic subject for a novice. This tabby stayed asleep in the sunshine for a few hours, longer than I needed to complete my study.

Again, before starting the sketch that I intended to work into a finished drawing, I had made several quick line drawings of the cat over a couple of days, in various positions and from different angles. I didn't worry about trying to describe his fur markings in these sketches; I just wanted to get some practice in creating his contour outline. This preparatory process familiarized me with his shape and character.

On the morning that I started this study, the light was perfect for me to see the detail of the cat's tabby markings and the warmth and silence of the spot meant that we could both be left undisturbed.

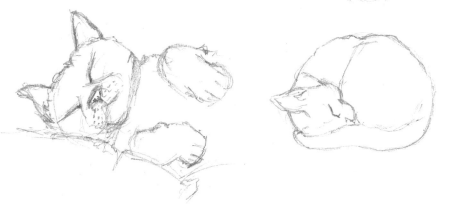

Materials and tools
HB propelling pencil
8B dark wash watersoluble
 pencil
Round watercolour brush,
 size 1
Eraser
Sketchbook
130gsm (60lb) smooth
 cartridge paper

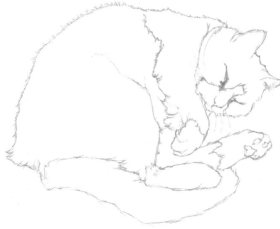

Step 1
Using an HB propelling pencil, I lightly sketched the outline and features of the cat. I built upon this initial sketchy outline once I was satisfied with the placement of my lines, using short, irregular marks along the contour lines to evoke the fur texture.

Step 2

I then began to map out the striped markings of the fur. Putting in this marking early helped to evoke three-dimensional form and establish the physical presence of the sleeping cat. I plotted the marking using simple lines, which meant that the position of the lines could easily be erased and revised if I wasn't happy with their location.

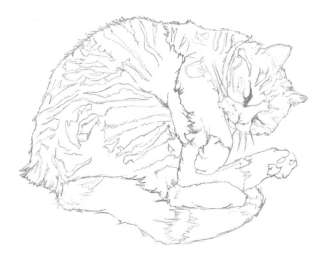

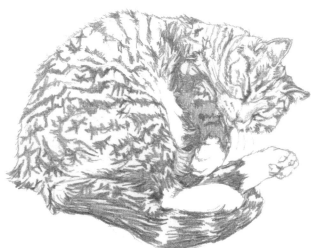

Step 3

Using the watersoluble pencil, I blocked in the dark stripes of the markings and the other shaded areas of the cat's body.

Step 4

I wanted to soften the sketchiness of this shading to create a smoother transition of tone, so I blended the shaded areas with the moistened watercolour brush and dragged some of the dissolved pigment into the white areas between the dark stripes to establish a mid-tone between the dark and light.

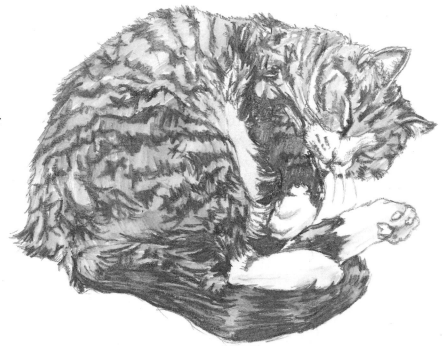

Drawing a duckling from life

Ducks make wonderful pets, especially if they have been hand-reared. One of my friends rescued an abandoned egg, incubated it and looked after the duckling once it was hatched. The result was a very tame, pretty little duckling, a perfect subject for me to use as a model for my drawings.

All baby animals seem to have far more energy than their adult counterparts, so they are a far more challenging subject to draw from life. However, capturing the beauty of a young animal is reward enough to inspire you to persevere with your time and energy.

The overall shape of a duckling is really very simple, comprising a tapering egg-shaped body, short neck, round head and flattened beak. The form is relatively quick to capture in just a few gestural lines. The duckling darted around in front of me while I made a few simple sketches in preparation for my final drawing, sometimes pausing long enough for me to accurately record its form.

Materials and tools
HB propelling pencil
8B dark wash watersoluble
 pencil
Round watercolour brush,
 size 1
Eraser
Sketchbook
130gsm (60lb) smooth
 cartridge paper

Step 1
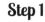
I settled upon a three-quarter view of the bird, based loosely on one of my preparatory sketches. I started my sketch by laying in a simple outline with an HB propelling pencil.

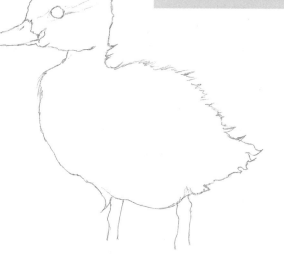

Step 2

I then started to plot the position of the markings, a process that's relatively easy to accomplish even with the subject running around. I used short, broken lines to evoke the markings and emphasize the fluffiness of the duck down.

Step 3

Using my watersoluble pencil, I roughly darkened the shaded areas of the duckling's body, applying more pressure with the pencil on the paper to create the darkest tones.

Step 4

I began to blend this shading, using the moistened watercolour brush and making quick flicking motions to create a soft, feathery texture. I dragged some of the pigment into the light areas of the drawing to create more subtly shaded areas around the duckling's underbelly and head. Finally, I added some random lines around the legs to suggest the grass upon which it is standing. I made a final wash on this grassy patch to blend and soften the lines.

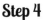

Translating a photograph into a drawing

Photographs are a great resource for any artist. Not only do they allow you to create your drawing at leisure, they also enable you to draw animals to which you may not have everyday access. However, while photographs can make your life easier, try not to let them control your drawing style; instead, use them as a reference that can be adapted to suit your own visual intentions.

Squaring up a photograph is a great way of planning the size and proportions of the subject you intend to draw.

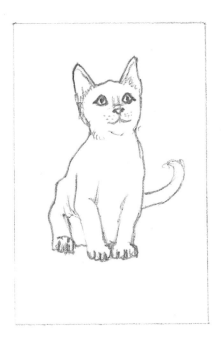 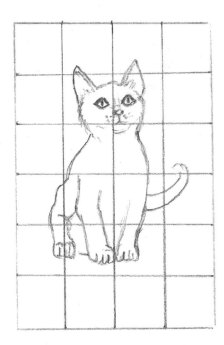

Steps 1 and 2

For your reference photograph, choose one that you don't mind drawing on. Using a fine-pointed marker pen or biro that won't smudge upon the glossy surface, draw a rectangle around your subject, choosing a length and width that are easily divisible.

My example was 6 × 4cm and I drew a grid of 1cm squares, six down and four across, over the image of the seated cat. (If you are using imperial measurements, a rectangle of 3 × 2in and a grid of ½in squares will give a similar result of six squares down and four across.) For a detailed drawing such as I have done, you may find it easier at first to choose an animal that occupies the major space in a photograph and work on a larger scale than this.

Step 3

To enlarge or decrease the size of the image, you can now draw any rectangle that will divide into a grid of the same number of units. Draw the grid very lightly, as you will need to erase the lines once you have drawn in your image. I doubled the dimensions of my original image so that the length of the rectangle was 12cm and the width was 8cm; the grid was made up of 2cm squares. The next step is to start planning your drawing by comparing where the outline of the animal crosses the lines on the grid. Here I have begun to place small reference marks upon the grid that can be linked to form an accurate outline.

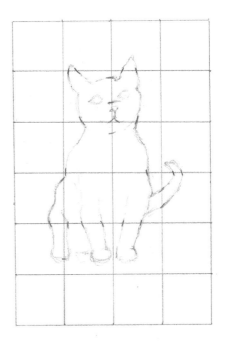

Step 4

Once you're happy with your drawing you can carefully erase your grid and begin to add detail to your drawing to give the image life and substance. Don't be restricted by what you see in the reference photograph – you may want to draw in a different background to add an individual touch to your finished work.

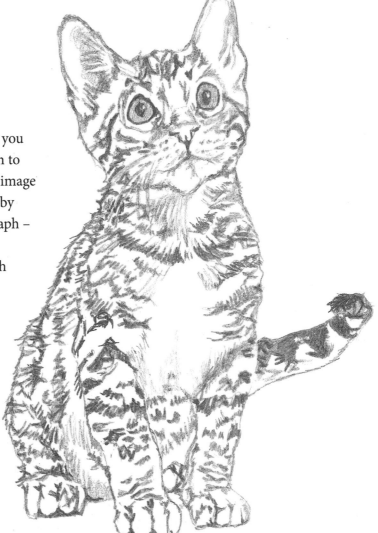

Drawing a budgie from a photograph

Once you have learnt how to square up a photograph and use a grid to plot your drawing you can use this method over and over again. I found a beautifully clear photograph of a budgie sitting on its perch; all the intricacies of its feathers were perfectly visible and that was what I wanted to focus on. My final drawing is highly detailed and this was much easier to achieve with the help of a photograph. I used an HB propelling pencil throughout the course of making this drawing. Propelling pencils maintain a sharp, precise point without the need for sharpening, which means you can work without interruption.

I drew my grid on the surface of the photograph and then, on my paper, lightly drew a corresponding grid exactly the same size as that on the photograph.

Step 1

Using an HB propelling pencil, I began to lay in search marks to help me plan out my outline and then lightly sketched in the shape of the bird's body. Search marks are simply small indications made with the pencil upon the grid to help you locate the points at which the outline of the form you are drawing crosses a line. These points can then be linked together to establish the basis of your drawing.

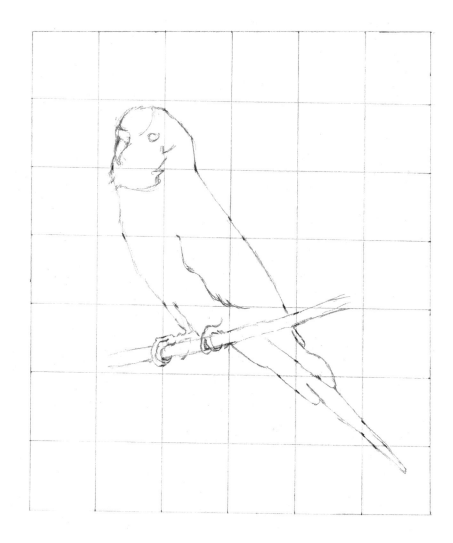

Step 2

Once I was happy with this faint outline I began to darken and refine the lines. I also added some texture detail to the breast of the bird and began to explain the basic structure of the folded wing.

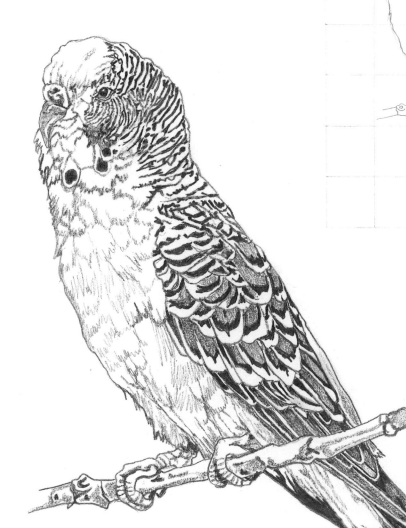

Step 3

Describing the detail of the budgie's feathers took concentration and constant reference to my photograph, observing how each feather interacted with the ones that surround it. The feathers on a bird's body are arranged in a very geometrical pattern, so I made sure this regularity and geometry were reflected in the pattern of my drawing.

Drawing a rabbit from a photograph

I found this photograph of my childhood pet rabbit, Domino. I still have fond memories of Domino and making this drawing was very enjoyable as it brought back lots of happy memories. This is another advantage of using photographs; you can create drawings of well-loved pets that are no longer with you. I used an HB propelling pencil throughout.

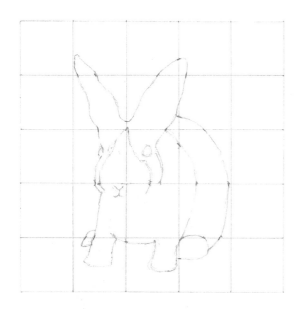

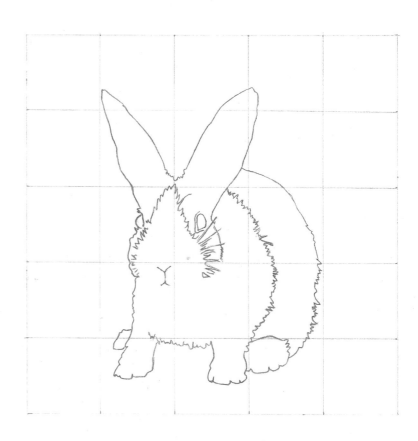

Steps 1 and 2

I used the squaring-up method we have looked at over the last few pages and began to plan the form of the rabbit, using search marks upon the grid (see p.50) and drawing in a light outline. I then strengthened these initial lines and added a jagged texture which begins to evoke the furry surface of the rabbit's body.

Step 3

I not only relied on the visual reference as it appeared in the photo but also drew upon the image of Domino and his character as it exists in my memory. I think this added an extra vitality to my final drawing of the rabbit. His striking black and white markings translate beautifully into a pencil drawing, creating a bold and interesting image. It can be hard to evoke texture in densely black fur – my tip is to start by making some really dark, closely spaced texture lines over the whole area. Make sure these lines follow and help to describe the contours of the animal's body. Over this dark pencil work, start to add a layer of lighter shading. This approach ensures that the area of dark fur appears black but still manages to include visual interest and texture details.

Working from a grid is great for building your confidence in creating correctly proportioned outlines and allows you to concentrate on the textural and surface detail of the animal's body. However, don't become totally reliant on the method as it's formulaic and can restrict your individual artistic expression. There really is nothing like drawing what you see as it exists in the world around you!

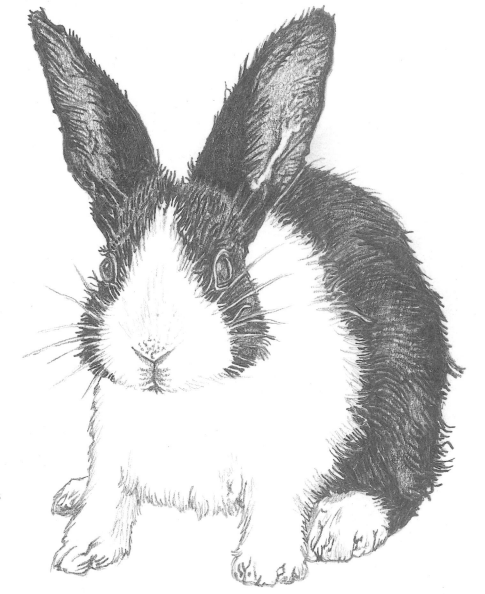

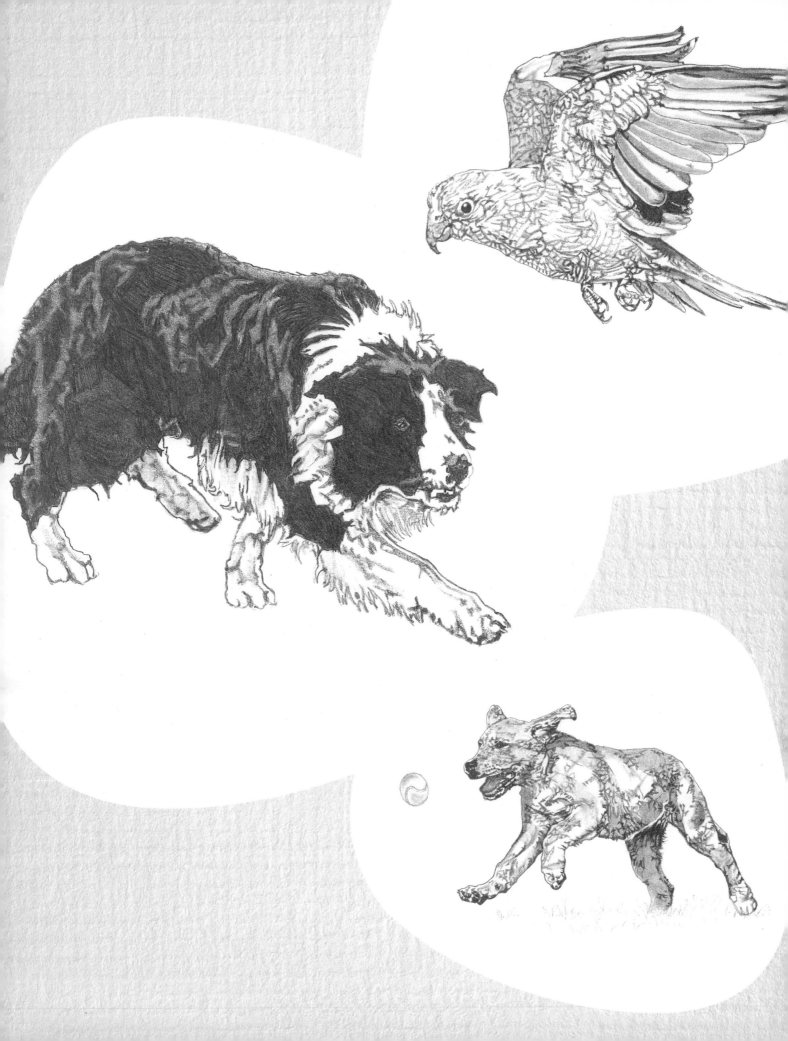

CAPTURING MOVEMENT

Since few animals are motionless for long, it's very important to start drawing your pets in active poses that will allow you to capture their characteristics and personality. In this chapter we shall explore different types of movement and how these are specific to different categories of pet – for example the fast bound of the dog, the stealthy slink of the hunting cat, the scurrying of the rodent or the graceful motion of the bird in flight. We shall also look at how the way in which a pet moves is often dependent on whether it's a natural predator or prey.

Throughout this chapter you'll find step-by-step studies of key types of movement which are embodied by particular pets to help you begin to create finished studies of the animal in action. Although the idea of catching a fleeting pose may seem daunting at first, taking a considered approach will soon show you that it's not as hard as it may seem.

Speed

There are many ways of evoking fast movement by adjusting the pose of your subject, such as stretching the legs and body to accentuate the forward-reaching progress of the animal. The surroundings of the subject can also be used to enhance the portrayal of forward motion – a blurred background can really help to instil the idea of speed within the mind of the viewer.

Here a whippet is extending its body in the midst of a high-speed run.

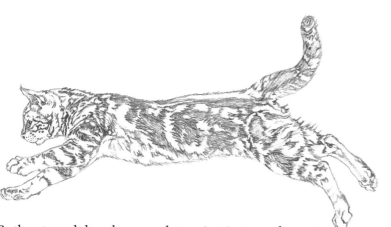

Both cats and dogs have predatory instincts, and most predators need speed in order to chase and catch their prey. These sketches of a tabby cat show the two key phases of the feline form running at full speed. The first shows all four legs outstretched, reaching out to cover the distance; the second shows the cat's body contracted with all the legs folded in centrally, making ready again for the paws to make contact with the ground for more forward momentum.

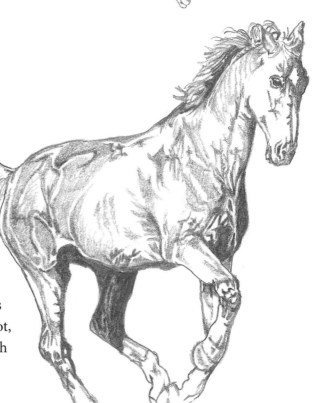

Horses are well known for their speed on the racecourse. The horse's gait has four stages: the walk, the trot, the canter and the gallop. This sketch shows the horse cantering – the equivalent of a fast jog.

Labrador chasing a ball

Most dog owners will be familiar with the ritual of throwing a ball or frisbee for their enthusiastic and persistent pet. Dogs love chasing, an instinct that comes from their ancestral roots as hunters, and ball games are not only a great way of tiring out an energetic pet but also allow you to watch the sequence of movements which are involved in the process of spotting, chasing and fetching the ball.

This drawing is made from a photograph of a beautiful labrador puppy, taken just as he was about to catch up with his ball. The picture is a great demonstration of speed, with the ball suspended in mid-air and the intent expression of the dog emphasizing the forward motion of the picture.

Materials and tools

HB propelling pencil
2B pencil
Eraser
130gsm (60lb) smooth
 cartridge paper

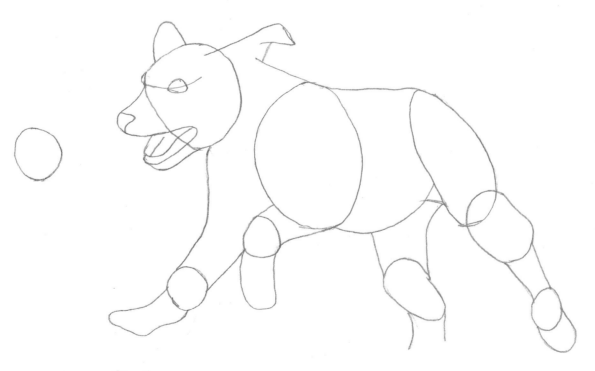

Step 1
Using an HB propelling pencil, I started by drawing out the shape of the dog, using simple forms. I added a circle at the dog's eye level to denote the position of the ball.

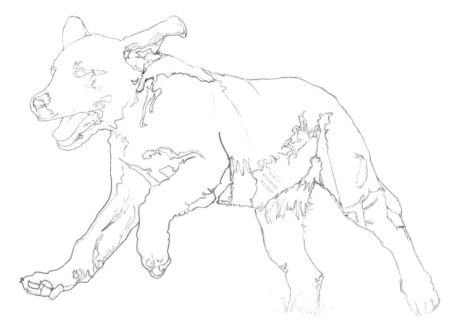

Step 2

Next I refined the outline of the dog and erased the preliminary working lines. I then began to sketch in the facial features and lines to show roughly where the light and shade fell upon the surface of the body.

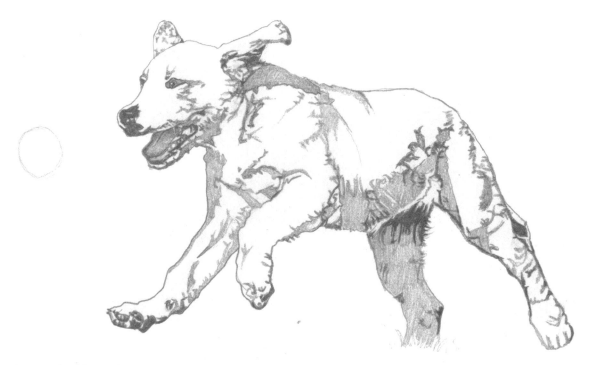

Step 3

Using a 2B pencil, I shaded in all the darkest areas of the dog's body. The drawing now really starts to convey the sense of the dog's three-dimensional form.

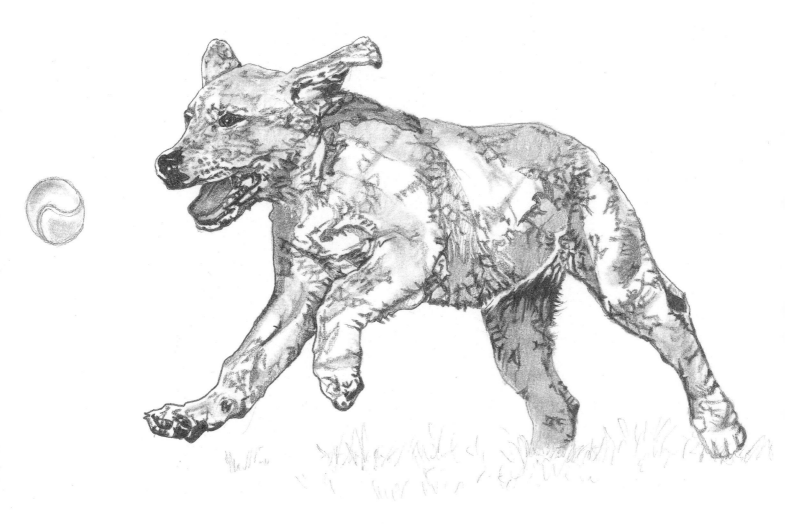

Step 4

In this final stage I worked on refining the shading and adding more subtle layers of shade and texture. I shaded the ball and added curved lines to it so that it took on a spherical appearance. Finally, I added sketchy lines around the feet of the dog to subtly suggest the grassy ground.

Behavioural characteristics

Cats are naturally skilful hunters and it is this hunting instinct that gives the cat its urge to stalk a prey, whether that may be a fly buzzing around the room or a favourite toy. These two sketches show the cat's posture and visual concentration when it is stalking. The posture is stealthy, poised and silent, as the cat tries not to alert its prey to its presence.

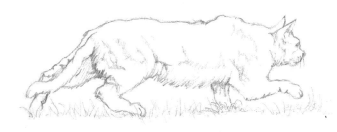

Dogs are also great stalkers, again a result of their predatory nature. Border collies are very intelligent dogs and their stalking abilities are famously used by shepherds for the herding of sheep. This sketch shows how the collie holds its body close to the ground and creeps along silently while focusing its eyes intently upon its prey.

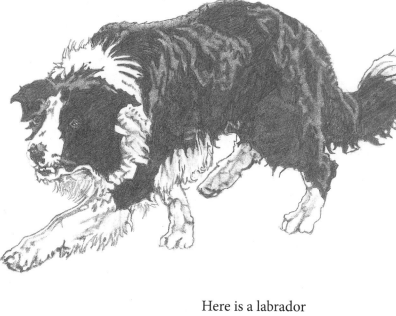

Here is a labrador puppy making a clumsy attempt at stalking. Puppies, like children, learn by imitating their elders' behaviour.

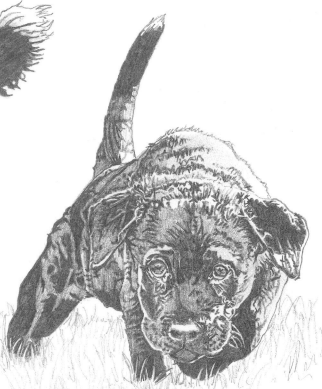

A stalking cat

I photographed a cat in my garden; it had seen a pigeon land on the ground and was utterly transfixed by it. I loved the bold contrast between the black and white markings of the fur.

Materials and tools
HB propelling pencil
4B pencil
Tortillon, or paper stump
Eraser
130gsm (60lb) smooth
 cartridge paper

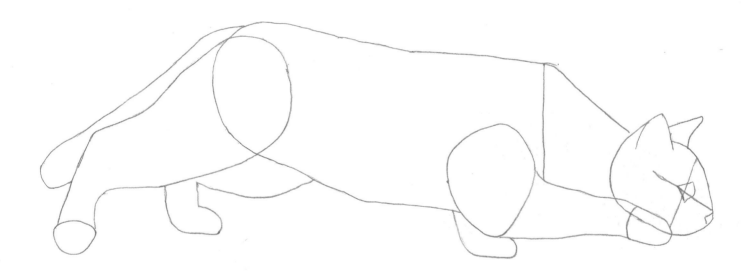

Step 1

For this first stage of the drawing I used an HB propelling pencil to ensure a clear, fine line. I wanted to accentuate the creeping stealth and concentration of the stalking cat, so when laying out my drawing I exaggerated the length of its body. To keep its whole stance very close to the ground, I emphasized the horizontals in my placement of the legs. The gaze of the cat follows the strong horizontal that runs through the length of its body.

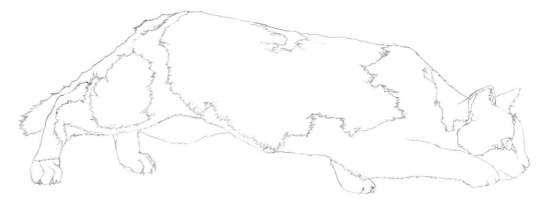

Step 2

I refined the outline and erased the preparatory guidelines, then began to draw in the lines that describe the location of the cat's markings.

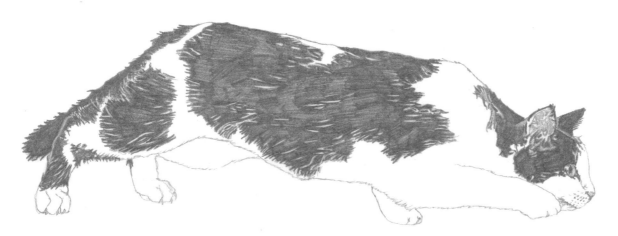

Step 3

Using a soft 4B pencil, I shaded in the black patches of the coat. I wanted to describe the texture of the coat as well as its colour, so I left tiny accents of white in the midst of the dark shading to convey the furriness of the animal. I worked on the eye, using the 4B pencil to shade the dark pupil, then lightly shaded the iris of the eye, making sure to leave a circle of highlight to emphasize the glassy reflectiveness of the eyeball. This also gives the eye an intense, concentrated expression.

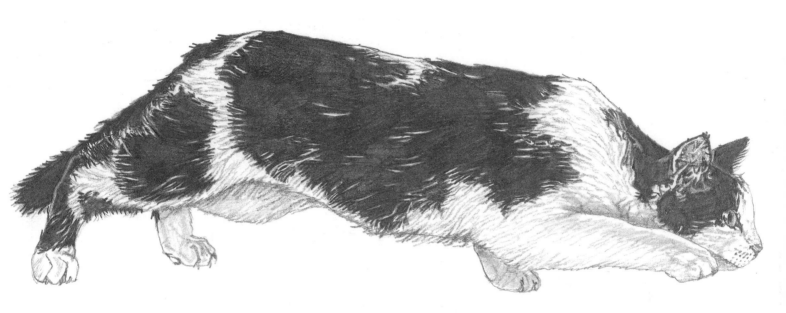

Step 4

I wanted to achieve a smoother look in the expanses of shading and so used a tortillon to blend these areas, making sure I maintained the white flecks. Finally, I began to add texture to the white fur around the black patches by lightly shading in lines which follow the lie of the fur upon the cat's body. This work also unifies the black and white patches, making the image more cohesive and ultimately emphasizing the solidity and presence of the cat in the process of its silent stalk.

Portraying flight

No matter which type of bird you wish to draw, there is a universal sequence of wing movements in the process of flying: the rapid flapping at the beginning of take off, the wide-open wings of the glide once the bird is airborne and the concentrated wing beat and outstretched legs that help the bird to land.

Parrots and budgies are tropical birds which, in the wild, live in groups in tree canopies and feed on fruits and seeds. This sketch of a soaring parrot shows how the body of the bird becomes entirely horizontal with wings outstretched to maximize their surface area and make the most of the air currents.

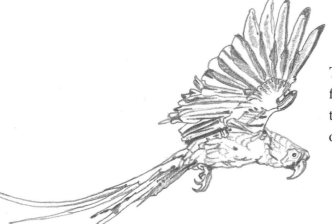

These two sketches of a parrot and budgie show the front and side view of the wings held back behind the body. This position can be either the process of the bird landing or taking off.

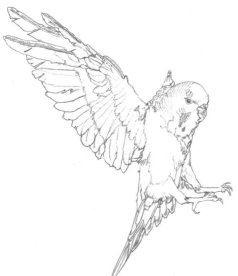

This image shows the budgie preparing for landing. The wings are angled wide on each side of the body to act as parachutes against the air currents and slow the momentum of the descent, while the legs and feet are outstretched in preparation for landing.

Parrot in mid-flight

I found a beautiful picture of a parakeet and fell in love with its quirky expression and the symmetry of its wing position. While the form of the wing and the feathers that make it up appear very complicated structurally, they are not in fact difficult to reproduce. Once you have practised drawing wings a few times you will see how the composition of the feathers is based on a very regular pattern. The body of the bird is straightforward and easy to master.

Materials and tools

HB propelling pencil
8B pencil
2B pencil
Eraser
130gsm (60lb) smooth
 cartridge paper

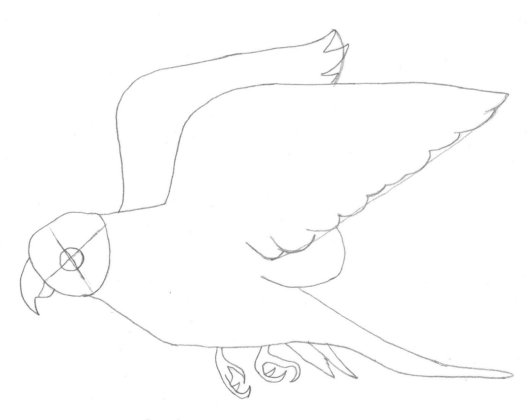

Step 1

Using my HB propelling pencil, I started by drawing in the simple forms that make up the bird; I didn't want to worry about describing individual feathers at this point. I laid in the shape of the wings using uncomplicated straight lines, then used the straight diagonal of the nearest wing as a guideline along which I began to plan how the feathers would eventually be placed by putting in a scalloped edge.

Step 2

By following this scalloping I extended lines to the apex of the wing, and these lines begin to describe the interlocking pattern of the wing feathers. I refined the rest of the outline and erased the preliminary working.

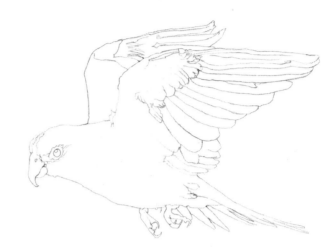

Step 3

I started to shade the edges of the wing feathers using a soft dark 8B pencil and then added a softer tone to each feather. I shaded in the dark beady eye of the bird, leaving the bright white highlight to add to the intensity of its expression. As I began to add detail to the beak and head, the picture started to take on a three-dimensional, tangible quality.

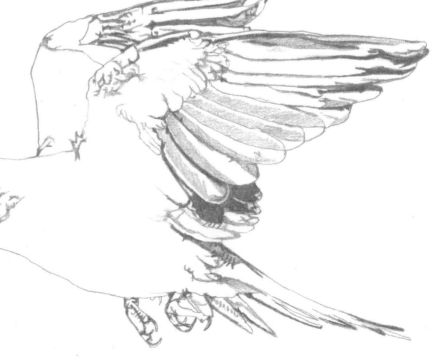

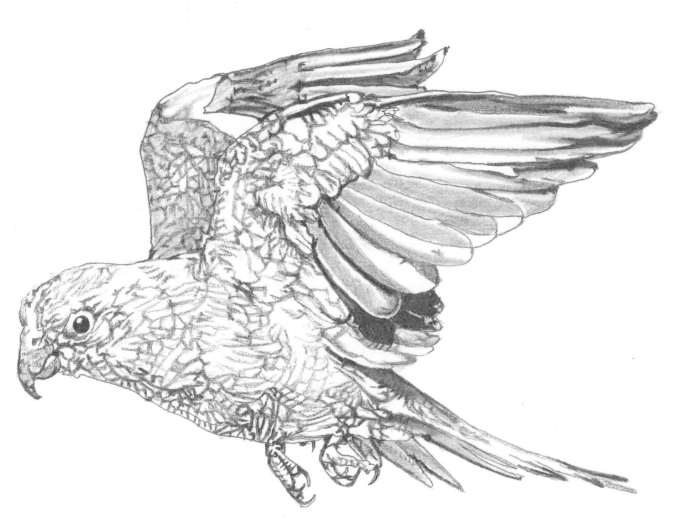

Step 4

Using a 2B pencil, I began to add a random subtle pattern to the body of the bird. Total accuracy wasn't needed when creating this pattern as it just adds interest to the drawing and conveys the idea of the soft, feathery covering of the body.

Hopping and scuttling

All small pets with short legs tend to either hop or scuttle quickly. Some, especially rodents, can be very fast, but this gait is different to that of a larger animal like a cat or dog. The short legs move rapidly in a scurrying motion.

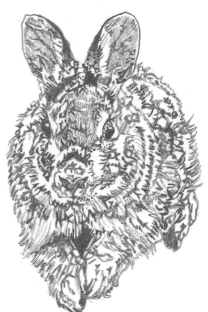

These sketches show a variety of small animal movements. The rabbit, chinchilla and ferret use a definite hop to get around, using their back legs to thrust the body forwards, while the front legs make momentary contact with the ground. Hopping creatures tend to have muscular rear legs and smaller, weaker front limbs.

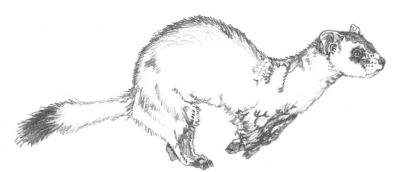

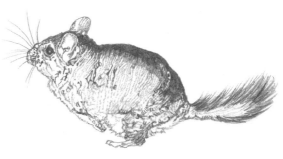

Mice are well known for their fast scurry. They are very agile and the long tail is used to help the mouse balance when running on uneven ground.

Lizards also have a scuttling gait. This iguana uses its strong, muscular legs to move quickly along the ground.

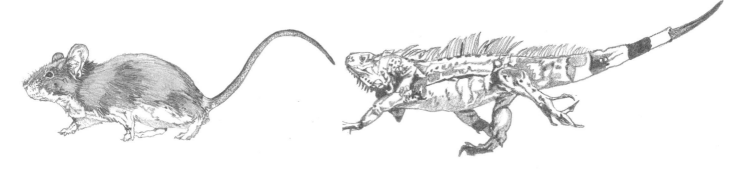

The guinea pig

Guinea pigs make wonderful pets and although they are naturally quite timid they respond well to handling and make great companions. Rodents are probably among the easiest pets to draw; their simple body shape and short legs are very easy to capture in a few lines.

Materials and tools

HB propelling pencil

2B pencil

4B pencil

Eraser

130gsm (60lb) smooth
 cartridge paper

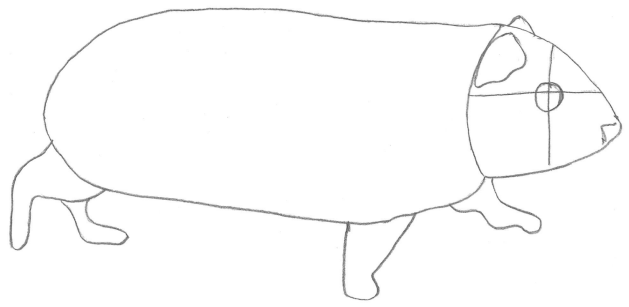

Step 1

Using my HB propelling pencil, I started this drawing of a guinea pig by drawing a simple elongated oval shape and adding a rounded triangle to one end. These shapes established the form of the head and body of the animal. Then I plotted the position of the eye and added four short legs to the underside of the body.

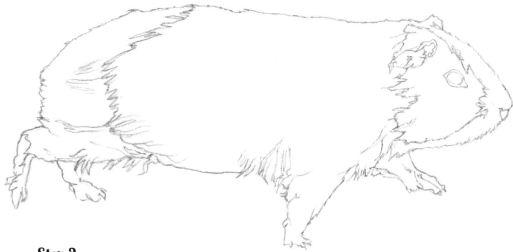

Step 2

I refined my simple outline and began to delineate the fur
markings upon the body of the guinea pig.

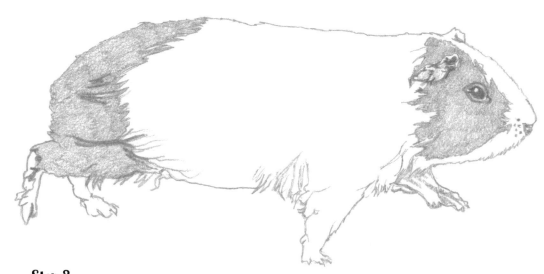

Step 3

Using a 2B pencil, I shaded the darker fur markings. I
darkened the eye, remembering to leave a small highlight.

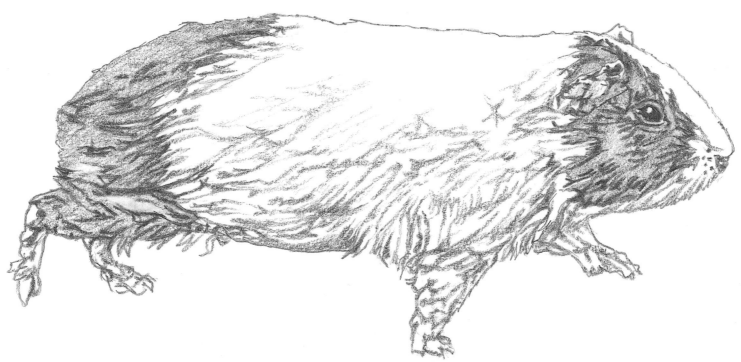

Step 4

Using an even softer 4B pencil, I added darker textural lines to the shaded fur, which began to convey the direction of the hairs of the animal's coat. I then softly shaded some fur texture in the white areas of the body, bringing the drawing together and uniting the light and dark areas of the body.

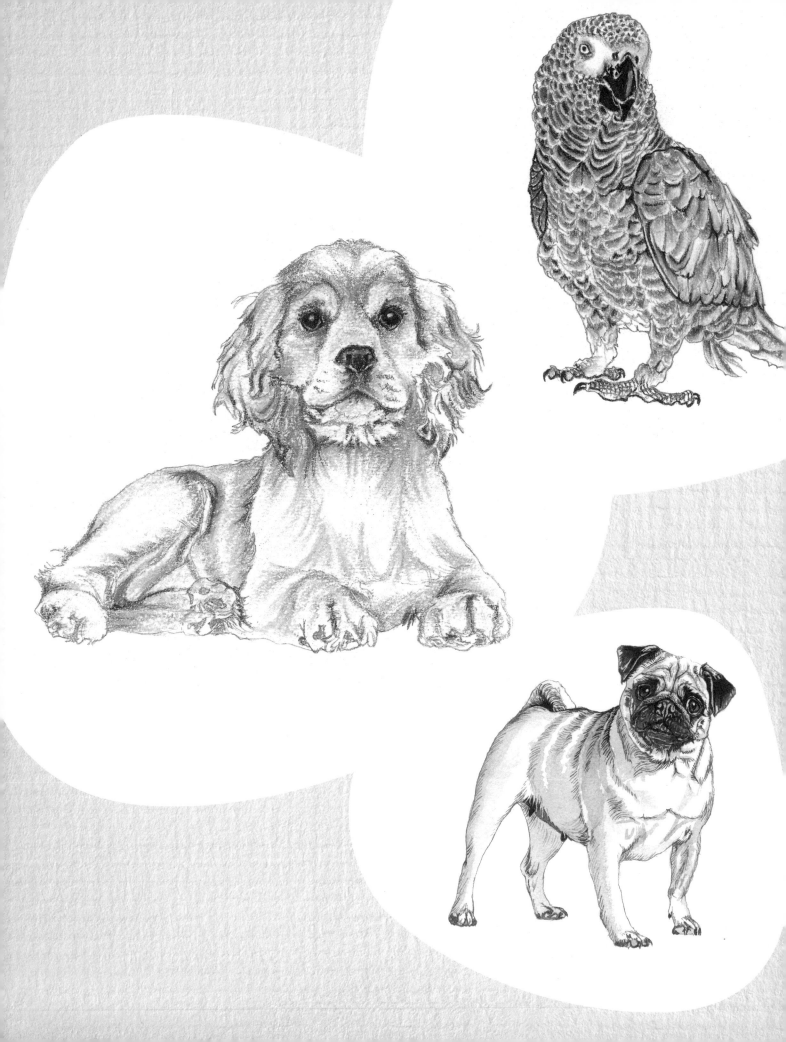

EXPLORING DIFFERENT MATERIALS

In this chapter we shall explore how different materials can be used to their best advantage to help you capture the essence of a particular pet. Here you will learn techniques specific to charcoal, watercolour, pastel and ink and see how I have created step-by-step pet portraits using each medium.

Even within a particular species there is wide variation in appearance, and once you have developed your skill with each medium you will be able to evoke an individual animal's particular character, too.

Charcoal

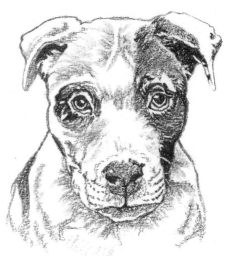

As charcoal can be used in much the same way as pencil, it's a good medium to start with when branching out into experimentation with different materials. Unlike pencil, it can be blended easily and it has a uniquely dark intensity. The effect can be bold and eye-catching and allows you to create dramatic tonal contrast between the black of the charcoal and the white of the paper. Charcoal comes in a variety of different forms, each with its own qualities and advantages.

Materials and techniques

Willow charcoal
This is sold in thin sticks, which are soft and brittle. It can be used to create soft shading and can also be sharpened to a point to work up detailed areas. Willow charcoal is both too thin and too brittle to be sharpened with a normal pencil sharpener; I find a craft knife or penknife is the best tool for the job. Take the piece of charcoal in your left hand and the knife in your right, blade facing away from your body (if you are right-handed). Holding the blade at a slight angle to the charcoal, use small, quick movements to scrape the end of the stick into a pointed end. Willow charcoal can be very smudgy and must be handled carefully to prevent unwanted marks on the paper.

Compressed charcoal Available in hard sticks, compressed charcoal can be used to block in areas of dense black shade. It produces a much more intense blackness than willow charcoal, which is much more sketchy and translucent. It is also far less brittle and crumbly and therefore a little easier to handle.

Charcoal pencils Sharpened to a point, charcoal pencils are capable of describing really fine details.

Tortillon Charcoal can be blended easily with a tortillon, or paper stump, to produce subtle tonal gradation from deep dark to light.
Paper The most important factor to consider when choosing a paper for a charcoal drawing is its texture – you need one with a grain to it so that the charcoal has something to adhere to. Look out for paper marked as having a grain; the heavier the grain the more textured the paper.
White chalk This can be very effective for creating highlights on charcoal drawings. It can also be blended with the charcoal on the paper, using a tortillon, to establish mid-grey tones.
Fixative The powdery nature of charcoal means that it can be smudged or rubbed right off the surface of the paper. Applying a fixative over your work once you have finished your drawing will help to preserve the image. You can buy specialized chalk and charcoal fixatives from art shops, but a cheaper and more easily obtainable option is hairspray. Simply hold the paper you want to fix at arm's length and spray the fixative evenly over the surface of the drawing.

The Siamese cat

The contrast of the black of the Siamese cat's face, paws and tail with the smooth, creamy colour of its body makes charcoal the perfect medium with which to capture this elegant feline.

Materials and tools

HB propelling pencil
Charcoal pencil
Willow charcoal
White chalk
Tortillon
120gsm (75lb) fine cartridge
 paper

Step 1

I spent a morning with the cat and made this preliminary study from life while he was sitting on the windowsill in the sun. He remained still long enough for me to lightly sketch in his form. I used an HB propelling pencil for these preliminary sketches because it is soft enough to erase but hard and precise enough to create fine lines.

Step 2

I strengthened my sketchy outline and added detail to the ears. I also took the opportunity to erase some of the preliminary working lines which I had used to locate the features upon the cat's face.

Step 3

Using a charcoal pencil sharpened to a fine point, I began to darken the edges of the cat's ears, nostrils and eyes and emphasized the pupils. I wanted these areas to have an intense blackness and the charcoal pencil produces this intensity as well as allowing precise application. To render the face, legs and tail a less intense black than the eyes and ears, I used a stick of willow charcoal, which has a lighter, more blendable quality, to create the texture of fur, making small strokes with the end of the stick and following the lie of the cat's coat.

Step 4

With a tortillon, I blended the willow charcoal to produce a smooth, light base tone. Over this I applied another, darker layer of fur texture and detail with the charcoal pencil. I then turned to the willow charcoal again to add light texture to the cream fur of the cat's body. The cat has started to become a solid form and the dark and light areas are unified by this added texture to the body.

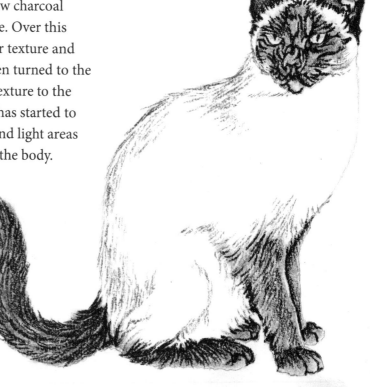

Step 5

I gently blended the darker top layer of charcoal into the lighter base so that the texture could still be seen. With my finger, I blended the strokes of willow charcoal on the body of the cat. I used the light residue of charcoal that stuck to my finger to lightly shade the whole of the body so that it became a tone darker than the background paper. Finally, I added a few highlights to the edge of the cat's nearest leg and the tips of his toes with a piece of white chalk, then sprayed the drawing with fixative.

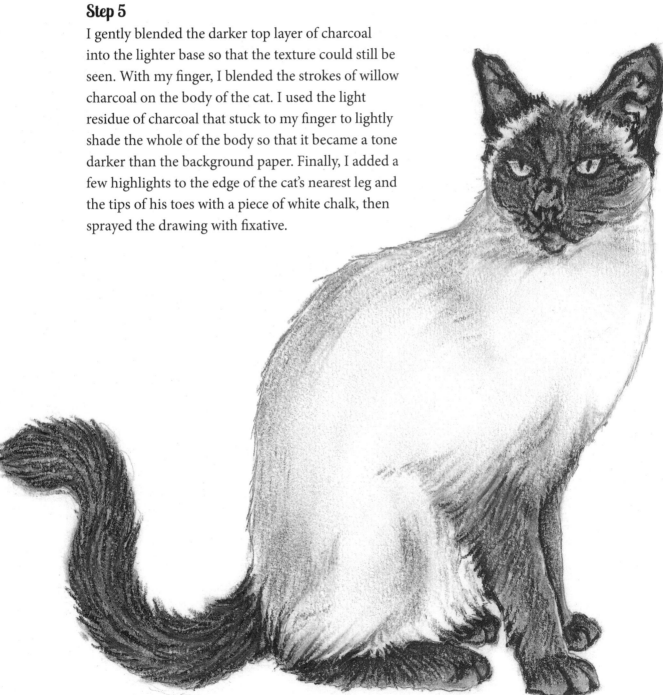

The African grey macaw

Parrots are highly intelligent and make very engaging pets. Drawing their arrangement of feathers is enjoyable – even though it seems a complicated task, it's in fact quite formulaic. I used a photograph of an African grey macaw as reference for my drawing; the grisaille colouring of this beautiful bird makes charcoal a particularly suitable medium for it.

Materials and tools
HB propelling pencil
Charcoal pencil
Willow charcoal
White chalk pencil
120gsm (75lb) fine cartridge
 paper

Step 1

I started by roughly sketching the form of the bird, using an HB propelling pencil.

Step 2

Next I began to add detail to the bird's face and refined the outline. I added a scalloped line near to the edge of the wing, which starts to indicate where the feathers of the wing will be located.

Step 3

Using my charcoal pencil, I shaded in the most immediately obvious dark parts of the bird – the beady eye, beak and claws. Then I began to draw in the feathers upon the body and wings using my HB propelling pencil, noticing the pattern they formed and the relationship between each feather.

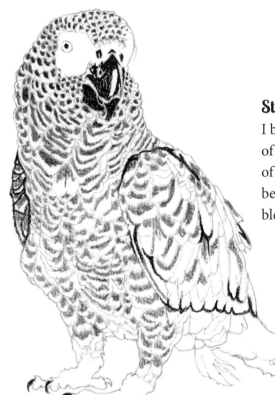

Step 4

I began to lightly shade the base of each feather, using a stick of willow charcoal for the job because it is soft and can be blended easily.

Step 5

Next I used a white chalk pencil sharpened to a point to blend out the charcoal on each feather. It was a perfect tool for the job because the point can be made fine enough to blend small areas and also the whiteness of the chalk produces a grey mid-tone between the black of the charcoal and the white of the paper. I left the white of the paper around the tip of the feathers to maintain their delineation against the charcoal shading. Once I had finished my blending I added some darker tones to the base of some of the feathers. Finally, I added some cross-hatched lines to the feet of the bird.

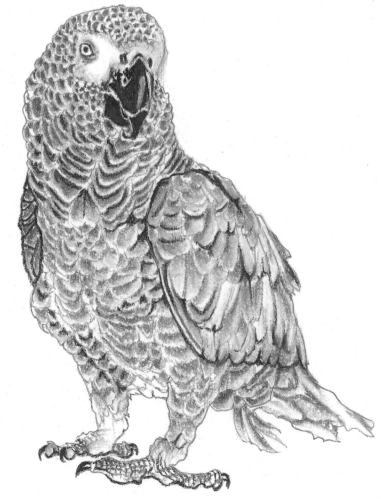

Watercolour

If you are new to the discipline of painting, watercolour is a great place to start. The results are beautifully immediate and fresh and by learning a few key techniques you will be able to create some outstanding pieces.

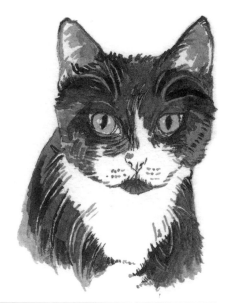

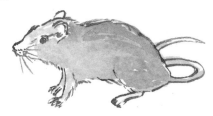

Materials and techniques

Watercolour paint You can buy watercolours in either tubes or small hard blocks, known as pans or half pans, depending on their size. It takes a little time to dissolve the pigment in block form, so the tubes are preferred for speedier colour mixing of large volumes of paint.

Watercolour paper As it needs to be robust enough to retain its form when flooded with water and pigment, watercolour paper is quite heavy. I use a 300gsm (140lb) Bockingford watercolour paper. Thinner papers tend to cockle (lose their flat surface) or degrade when water is added to the surface.

Brushes You should have a variety of brushes at your disposal. Wide, flat or chisel-ended brushes are great for laying in a preliminary light wash in one bold stroke. Round brushes with a pointed tip come in a variety of sizes; they can be used to draw fine lines and detail.

Washes It is good to start with a wash when beginning a watercolour drawing. The wash forms a light mid-tone base, which can be darkened gradually. Mix up a dilute solution of pigment using a wide, flat brush and apply to the wet paper in broad, sweeping strokes.

Wet-on-wet This technique can produce some wonderful spontaneous effects. With a large flat brush, apply clean water to the paper to saturate the area you want to work on. Using a size 1 round brush, mix up a pigment-heavy paint solution. Load your brush with it and touch the tip of the brush onto the wet surface of the paper; the paint will slowly spread into the paper and bleed around the edges, producing soft, undefined shapes. The wetter the paper the more the paint will bleed. This uneven pigment dispersion can create a beautiful smoky effect.

Dry brush This technique is useful for creating fine detail that stands out to the eye. Mix up a pigment-heavy solution using very little water so that you achieve a dark intensity when making a line.

Lifting off This technique allows you to make slight changes and add highlights even after you have applied the initial wash of paint. Wet the area of paint that you want to remove and then use a tissue to blot away the excess water, taking the unwanted pigment with it.

The pug

I love the direct, knowing gaze of the pug and it was this look that I wanted to capture in a painting. I was dogsitting a beautiful pug bitch for a friend and seized the opportunity to take some photographs. A good way of getting your canine subject to look alert and engaging in a photograph is to hold a favourite toy or treat in your hand – this will hold the dog's gaze and keep him or her still for long enough for you to take a nice shot.

Materials and tools
HB propelling pencil
Flat watercolour brush, size 1
Ivory Black watercolour
 pigment
Round watercolour brush,
 size 1
300gsm (140lb) watercolour
 paper

Step 1

I thought watercolour would be a good medium with which to create my drawing, allowing me to capture the immediacy of the expression as well as to put in some fine detail. I began by sketching the body of the dog and plotting the position of the facial features with an HB propelling pencil.

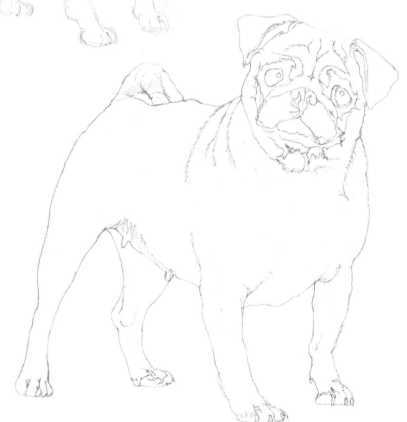

Step 2

I refined the outline and added detail to the face and body, describing the facial creases and erasing some of the preparatory working.

Step 3

Using a flat sable brush, I mixed a very dilute wash of black, taking only a tiny amount of pigment from the pan and then adding a couple of brushfuls of water to the mixing palette. I applied this base wash to all the shaded areas of the dog.

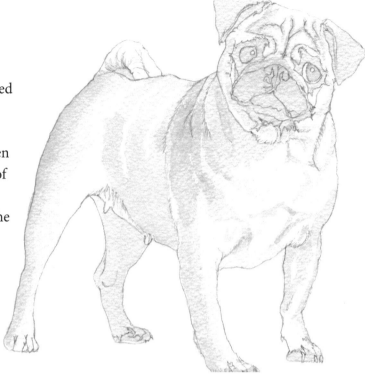

Step 4

I mixed up a slightly stronger solution and used my small round brush to create the distinctive black face, ears and large, dark, shiny eyes. I also used this darker mix to add detail to the toes.

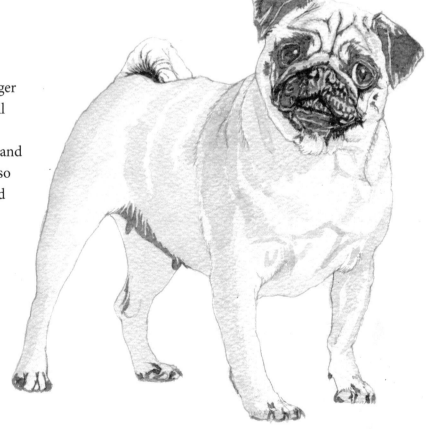

Step 5

After using the dry-brush technique to add further depth and detail to the dark areas, I added some stippling detail to the face to evoke the shadows around the skin folds. Finally, I mixed a slightly more dilute paint solution and carefully brushed in fine lines upon the body to suggest the texture of the fur and add to the three-dimensional presence of the dog.

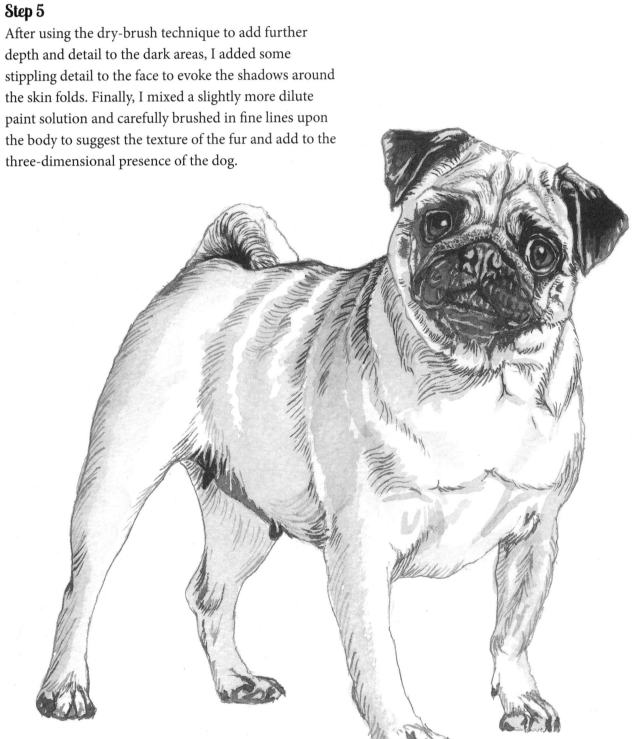

Oil pastel

While oil pastels aren't the easiest medium to work with, it's well worth putting in the time and practice to discover how to make the most of them. Here I have outlined a few key but simple techniques to put you on the right path, and once you have mastered these you will have the confidence to explore the medium further.

To begin with, choose a simple, bold subject without much detail, such as I have shown here; although you can draw fine detail with oil pastels, it does take practice and initially can be quite frustrating. In my study of a guinea pig (above), you can see how I have focused on describing the distinctive shape and the contrast between light and shade upon the surface of the body without worrying about the detail.

Materials and techniques

Black, white and grey oil pastel sticks While artist's quality pastels are a little more expensive than the student's grade, it's worth paying extra. High-quality oil pastels have a smoother texture and higher pigment content and are much easier to handle. I use the Sennelier brand of oil pastels; they are a little pricier than the average but, for me, produce the best results.

Fine grain cartridge paper Use a paper with a minimum weight of 160gsm (98lb) and a slight grained texture to the surface. Heavier paper is better able to absorb the oil content of the pastel and the grain helps the pastel to bond with the surface of the paper.

Palette knife This is handy for scraping pastel off the paper, which allows you to create texture and change the tone of your image where you wish to.

Blending Use a tortillon – a paper stump with a pointed end – for blending the pastels on the surface of the paper. Alternatively, you can simply use your fingers instead. This is the easiest method of blending, as the warmth of your fingers helps to make the oil in the pastel more malleable.

Holding the pastel stick How you apply the pastel stick to the paper and the pressure you exert on it both make a considerable difference to the mark that is made. Below, the side of the pastel stick was rubbed onto the paper. Using this method allows you to block in large areas of pigment.

To make thick, opaque strokes, hold the pastel vertically and use the flat end.

Scumbling Use the side of the pastel stick and softly drag it over the surface of your paper. This creates a broken covering of tone, which adds texture and depth. A scumbled layer can also be applied over a layer of base pastel.

Clean rags or paper towels Keep these handy to wipe up any mess created by stray crumbs of pastel. Rags can also be used for blending.

The chinchilla

The natural habitat of chinchillas is the higher altitudes of the Andes in Peru, Bolivia and Chile, and their beautifully soft, dense coat is essential to their survival in extremely cold temperatures. I felt that the smooth creaminess of oil pastels would make them a great medium with which to capture the appearance of chinchilla fur. I have two chinchillas and they are ideal pets to draw because they are nocturnal and sleep for long periods during the day, giving me plenty of time to study them.

Materials and tools

HB propelling pencil
Mid-grey, black and white
 pastel sticks
Palette knife
160gsm (98lb) Ingres pastel
 paper

Step 1

I made this preliminary sketch, using an HB propelling pencil, while the chinchilla was asleep. I used my imagination to add the open eye and upright stance, so that she appears to be awake.

Step 2

I refined the outline and then began to add some detail to the ears, legs and nose.

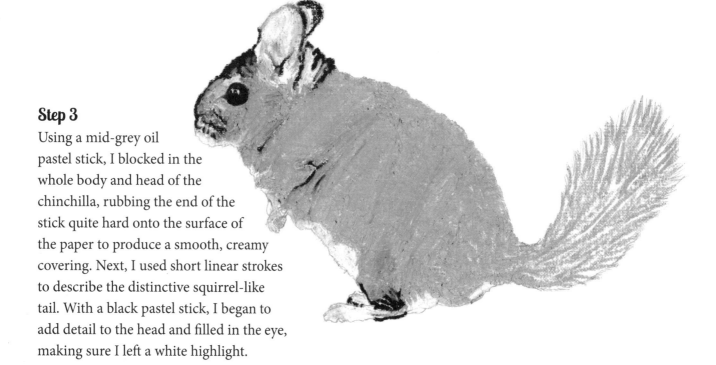

Step 3

Using a mid-grey oil pastel stick, I blocked in the whole body and head of the chinchilla, rubbing the end of the stick quite hard onto the surface of the paper to produce a smooth, creamy covering. Next, I used short linear strokes to describe the distinctive squirrel-like tail. With a black pastel stick, I began to add detail to the head and filled in the eye, making sure I left a white highlight.

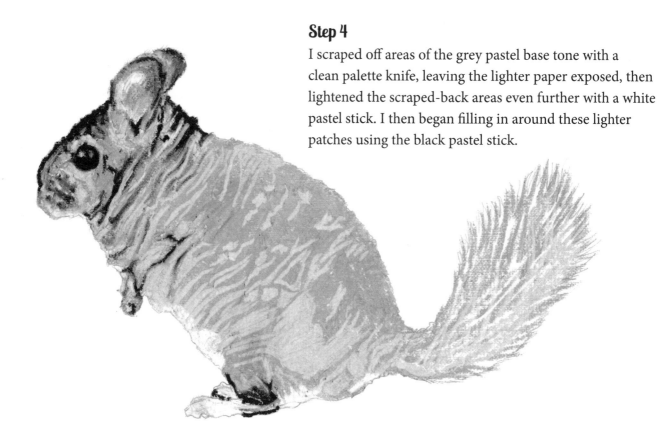

Step 4

I scraped off areas of the grey pastel base tone with a clean palette knife, leaving the lighter paper exposed, then lightened the scraped-back areas even further with a white pastel stick. I then began filling in around these lighter patches using the black pastel stick.

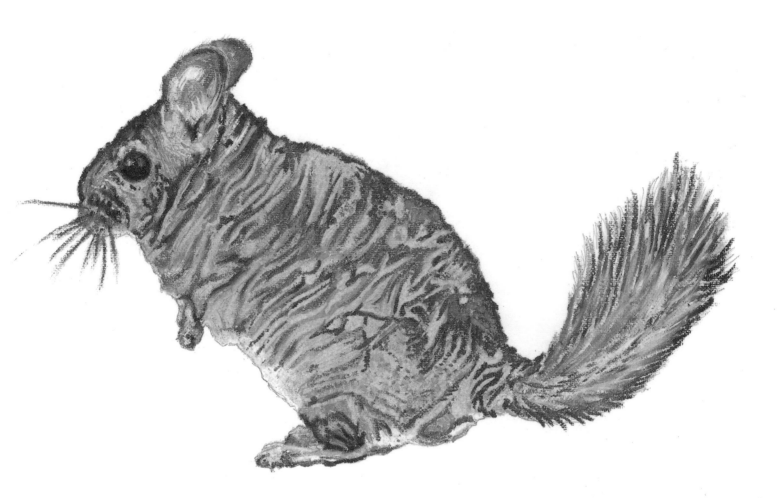

Step 5

With the black pastel, I continued to darken the spaces between the light lines to evoke the dense texture of the chinchilla's fur. I added dark and light lines to the tail to make it a dense, textured brush. Finally, I added whiskers to the nose, using a series of fine black lines.

Soft pastel

Artist's soft pastels are a very permanent medium because they contain no liquid binder and are made up of nothing but pigment held together in a stick with a small amount of gum binder. There is nothing in the pastel that can corrupt or change its colour over time, so your drawings will remain bright and fresh. Soft pastels are slightly easier to work with than oil pastels; they blend readily and have their own unique velvety finish.

Soft pastel can be applied in loose, sketchy strokes to produce a vibrant and immediate image; it can also be used in a more painterly way by rubbing the pigment hard into the grain of the paper to produce more opacity. Blending to gradate tone and colour and scumbling can be employed in much the same way as with oil pastel (see p.84).

Materials and tools

Black, white and grey soft pastel sticks There are many brands available, varying in their softness according to how much binder is used. I find Faber-Castell soft pastels a pleasure to use and they are not among the most expensive options.

Fine grain cartridge paper While it's not essential to use a paper with a high gsm as is the case with oil pastel, it is advisable to choose one with a grain to provide a 'tooth' to which the pigment can adhere.

Tortillon Use a tortillon, or paper stump, with a pointed end to blend the pastel pigment on the surface of the paper.

Soft and hard bristle brushes Brushes are useful for smoothing, blending and even removing pigment from the paper.

Rags and paper towel You will need these to keep your hands and workspace clean, as soft pastel smudges easily. You can also use rags to blend pigments.

Fixative Soft pastels are drier than oil pastels and therefore more likely to smudge; because of this it's advisable to use a fixative spray on your finished work to preserve the image. Choose one that is specific to pastels.

Cocker spaniel puppy

Their large, soft, silky ears and wavy coat make cocker spaniels very distinctive. The smooth, subtle qualities of soft pastel make it an ideal medium for drawing one, so I looked for a photograph and fell in love with this cocker puppy's confident stare.

Materials and tools
HB propelling pencil
Light grey, black and white
 soft pastel
Tortillon
120gsm (75lb) fine cartridge
 paper

Step 1
I sketched in the outline with an HB propelling pencil, plotted the location of the eyes and loosely drew some lines to show the fluffy ears.

Step 2
Next I strengthened the outline and began to plot lines to help me locate the borders between light and shade.

Step 3

Using a light grey soft pastel, I began to shade in the mid-tones on the puppy's head and body. It's best to work from light to dark and build up the shadows gradually, since establishing this mid-tone early helps you to recognize where the drawing needs to be darkened and where you need to leave bright highlights.

Step 4

Picking up my tortillon, I began to blend the grey pastel so that it appears soft and gradated. Then, using a black pastel, I darkened the nose and the eyes, leaving a bright white accent of highlight in the centre of the pupils. I began to apply white pastel to the light areas of the coat and also blended the grey further to achieve an even subtler gradation of tone.

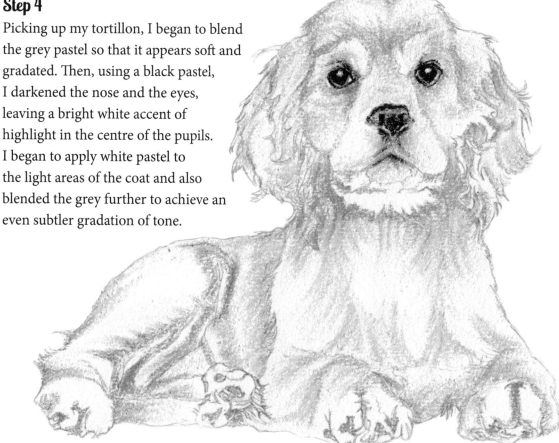

Step 5

I continued to blend the strokes of grey with the white pastel and added a few darker shadows to the curls of the fur and the edges of the mouth with the black pastel. I wanted to maintain a tonally subtle drawing to evoke the soft, silky texture of the puppy's coat, so I applied the black pastel sparingly.

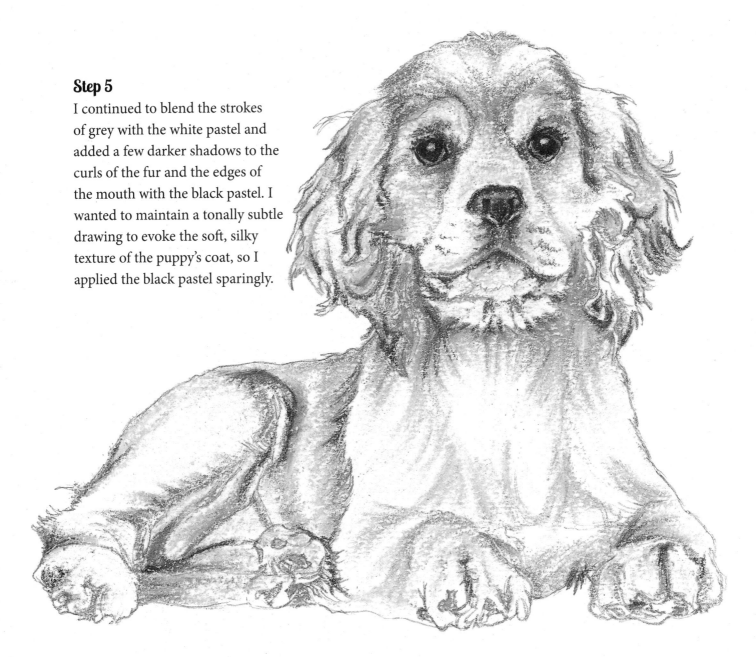

Pen and ink

Drawing with ink is a discipline which has been used throughout the centuries by many different cultures and there is a huge variety of techniques and styles, from the fine line and beautiful detail of Renaissance work to the bold, graphic styles of today's cartoons and comics.

Pen and ink drawings can be spontaneous and fluid or controlled and detailed, making this a fantastic medium with which to develop your own style by learning how to use the pure opacity of the ink in different ways to create a distinctive image. It is ideal for cross-hatching and stippling (see pp.10–11). Although there are plenty of fine art ink pens on the market, when you are starting out you can use any pen lying around the house – even a biro.

I drew these ink sketches of a tortoise, mouse and rabbit very quickly, which gave them an immediacy and clarity.

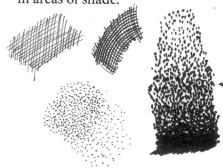

Materials and techniques

Staedtler pigment liner These ink pens are available in a variety of sizes, from 0.1mm for a really fine line to 1mm for a thicker, bolder line.

Brush pen This is like a felt-tip pen but with a brush instead of a nib. It is excellent for blocking in solid, opaque areas of shading.

Indian ink, dip pen and brush Once you have practised the pen and ink technique using ink pens, you will probably want to progress to experimenting with Indian ink. It takes further practice to master the materials, but it is the most traditional way of creating ink drawings and is well worth the time spent. When the pen is dipped into the ink the nib stores a small amount of ink, which must be used immediately to create your lines. Watercolour brushes can also be used to transfer the ink to the paper. Brush and ink creates a more fluid line and is excellent for blocking in areas of shade.

The tortoise

Tortoises are great pets to draw if you want to make a really detailed image. They present a variety of textures and pen and ink is perfect for capturing the smooth and ridged areas of the shell and the rough, scaly skin. I used a photograph as reference for this drawing.

Materials and tools
HB propelling pencil
0.3 black pigment liner
Brush pen
220gsm (135lb) heavyweight
 cartridge paper

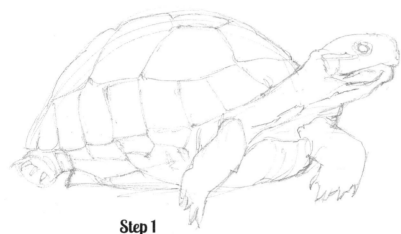

Step 1

I started by lightly drawing the curve of the top of the shell using an HB propelling pencil. After completing the simple oval of the shell I was able to plot the position of the legs and head. I then began to draw in the segments of the shell.

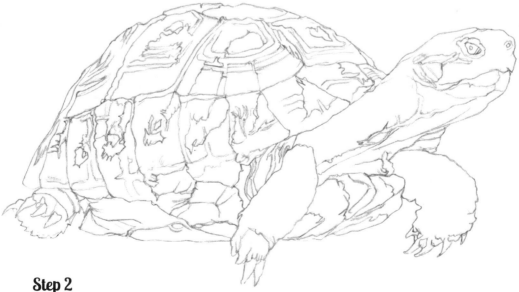

Step 2

This tortoise had a distinctive pattern of dark patches over the top of its shell. I began to draw in this detail and refine the outline of the entire form.

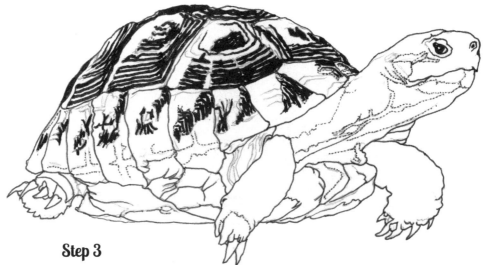

Step 3

With an 0.3 black pigment liner, I drew over my pencil outline, using a broken line to express the contour with less definition. I blocked in the dark patchy pattern of the shell with a brush pen.

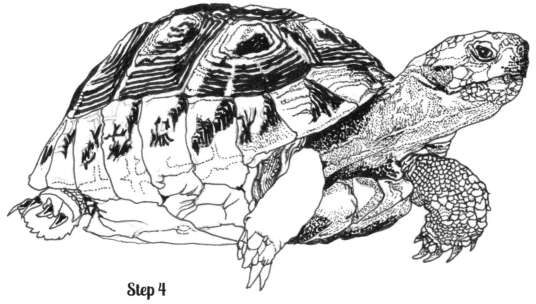

Step 4

In this stage of the drawing I worked on the rough scaliness of the head, neck and front leg. I used the brush pen to darken the area where the neck recedes into the shell and then turned to the 0.3 liner pen to create a stipple of dots that gradated the darkness into a lighter shade. I continued this stippling to create the texture of the rough skin of the neck. To evoke the small scales upon the leg, I drew a network of circles over its surface.

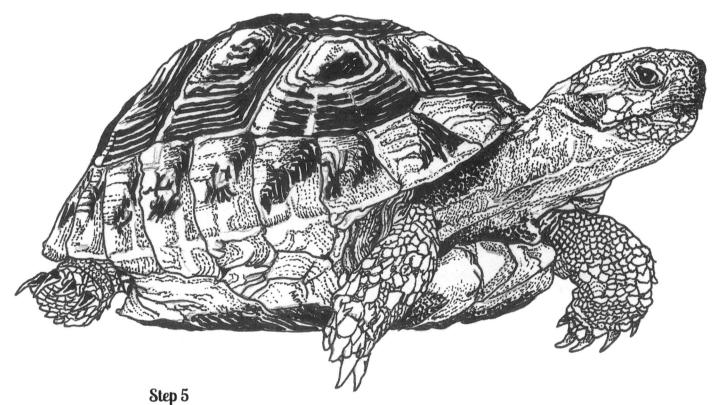

Step 5

Finally, I continued to stipple around the dark patches on the shell and drew in the scales on the remaining two legs. The finished drawing looks highly detailed, but you can see how easy it is to work up to this level of intricacy by using the stippling technique and paying close attention to surface texture.

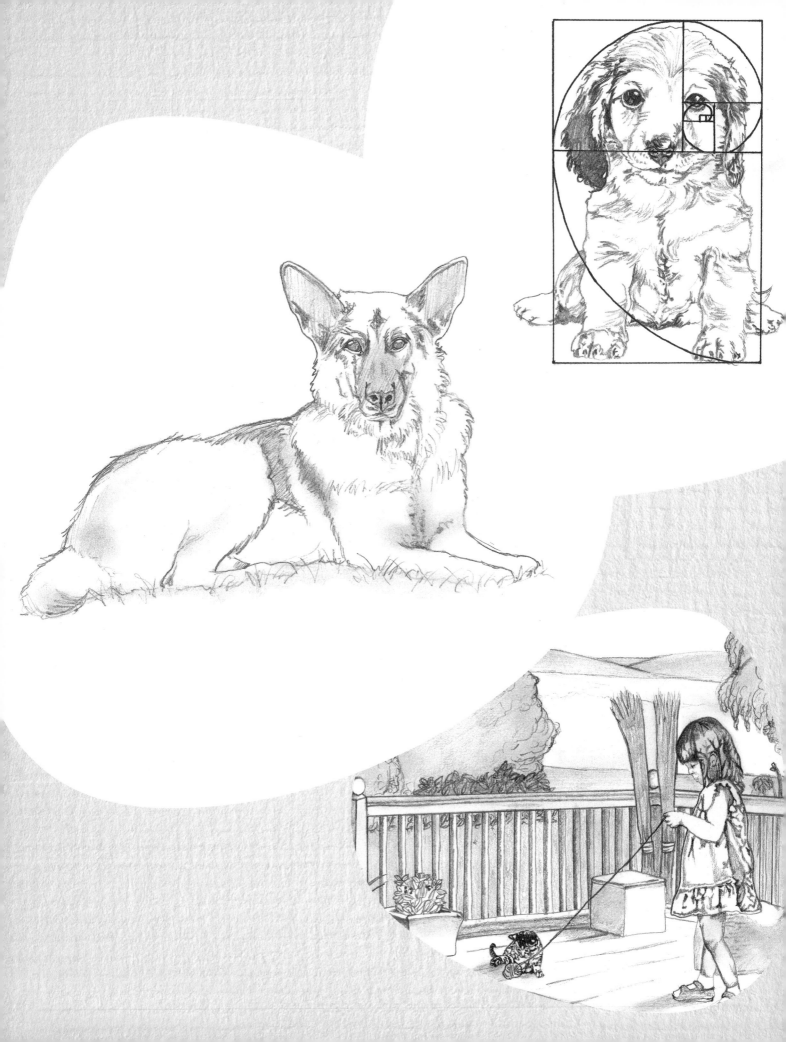

COMPOSITION AND ENVIRONMENT

So far, we have been concentrating on the techniques needed to create a beautiful drawing of an animal. Now we shall widen our focus to incorporate the environmental context and animal interaction, both with humans and with other animals. Understanding how to evoke the relationship between a pet and its owner and surroundings will allow you to experiment and develop your style so that you can make really interesting drawings.

In this chapter you will also learn how to make a strong composition that will hold the viewer's attention and guide the eye around the picture. I shall outline three different types of composition with step-by-step examples to demonstrate the process of making a picture, from planning it out using thumbnail sketches to the final stages of perfecting the design.

What is composition?

Composition is about arranging the elements you want to include in your picture in such a way that the overall visual experience is one of unity, harmony and balance. There are a few basic ideas, employed over centuries in Western art, that will help you to begin creating effective compositions. Following these rules when you are starting out and understanding why they lead to engaging pictures will enable you to experiment with them as your confidence grows.

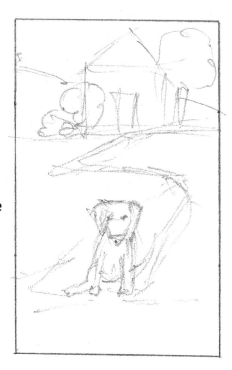

Making a strong composition requires planning and objectivity rather than just simply drawing what you see. It is almost like writing a story; even a brilliant initial idea will not hold the readers' interest without well-structured and well-written content.

Key elements of composition

There are several key elements that all effective compositions should contain in order to guide the viewer's eye on an interesting journey through the picture.

1. Choose an engaging primary subject. If your main subject matter involves the interaction between two or more elements, make sure that there is a visual link that makes their connection clear to the eye.

2. Use secondary supporting elements that enhance and complement the primary subject. These secondary objects can also be used as 'eye-stoppers' to discourage the viewer's eye from wandering off the borders of the composition.

3. Organize your composition around a simple shape such as a circle, triangle or L-shape to control the path of the viewer's eye around the picture.

4. Establish your source of light and make sure it is consistent throughout the picture as this will add to the harmony and unity of the composition.

5. Choose a backdrop that accentuates the presence of the primary subject. Negative space surrounding a subject can help to suggest substance and three-dimensional form. Do not allow a background to compete with, or otherwise detract from, the main focus of the drawing.

Planning your composition

Compositions do not spring fully formed onto the page; a good composition takes planning. A good way of experimenting with visual ideas is to make small, quick drawings known as thumbnail sketches. These can be regarded as a sort of pictorial shorthand which enables you to note down ideas as they occur to you. They can then be used in other drawings if they look promising or discarded if they do not.

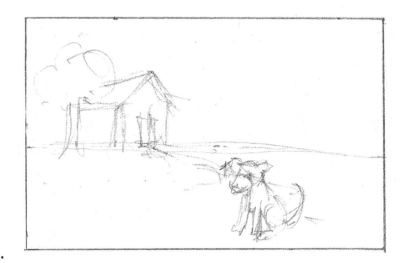

All good compositions start with an interesting subject matter, and once you have clarified in your mind what you want your drawing to convey, you can start experimenting with the placement of your key features. Make a series of thumbnails shifting the position of key elements in each sketch until you feel you have established an appealing and harmonious composition.

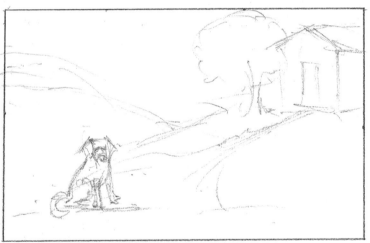

Your drawings can be very minimal – don't worry about details, just locate the figures using rough shapes. Define the outlines of important features and use hatched lines to block in areas of shadow.

Once you are happy with the general compositional layout in your thumbnail you can make a larger, more detailed drawing, using your sketched plan as a reference. Careful planning at this early stage in the drawing process will save you a lot of time in the long run and give you a clear understanding of what you want to achieve when you start your final drawing or painting. Having already planned where to locate your focal point and supporting elements and created a smooth pathway for the viewer's eye to scan the composition, you are free to start your drawing with confidence.

The golden section

One of the main precepts of strong composition is to base the design of the picture on the principle of the golden section (also known as the golden mean, rectangle or ratio). This is a mathematical equation that is present in natural forms such as the spiral shell of the nautilus, the formation of petals in a flower and even the ratios between parts of the human body. The fact that the golden section stems from nature probably accounts for why artworks and buildings made according to its equation are so pleasing to the eye. Artists have used the golden section to plan their masterpieces for centuries, from the sculptors of Ancient Greece and the painters of the Renaissance through to Modernist icons such as Mondrian and the architect Le Corbusier.

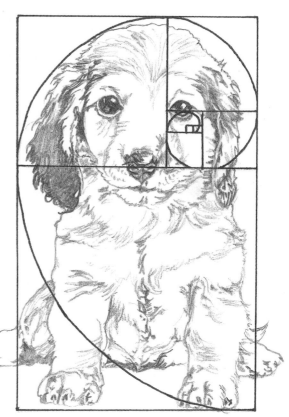

The complex mathematical rationale behind the golden section need not concern us; what is most important is the understanding of how a rectangular page or canvas can be divided to achieve a beauty and balance when you are designing your compositions.

This diagram shows the lines of division within the golden section. You can see that the vertical and horizontal lines are located nearly one-third of the way along the length and width of the rectangle. It is from the golden section that the idea of the rule of thirds evolved (see opposite).

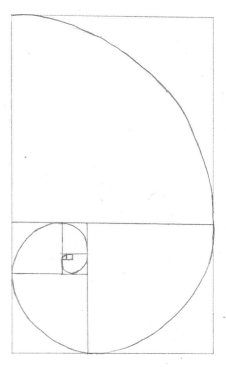

The rule of thirds

A simplified version of the golden section, the rule of thirds helps you to create a composition with tension, balance and interest without bogging yourself down in precise mathematics.

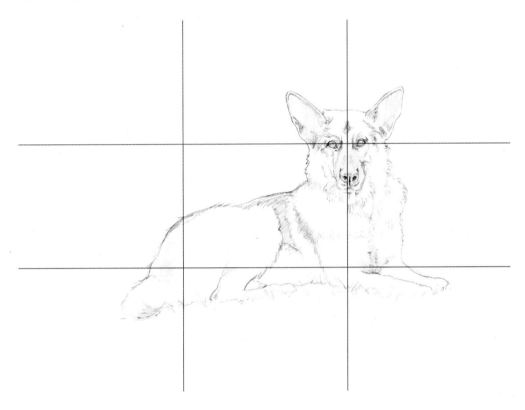

To use the rule of thirds, just draw lines dividing your page both horizontally and vertically into three equal sections. The points at which these lines intersect form areas of interest that the eye is naturally drawn to. Following this idea, you can begin to plan your composition by placing focal elements at these intersections.

Central composition

For creating paintings with only one primary subject, central compositions are very effective. Using the rule of thirds makes the organization of this type of composition easy; simply place your primary subject within the centre third of your grid. Background features radiating from the edges of the picture to the central focus help to keep the eye concentrated on your primary subject.

The standing cat

I wanted to make a dramatic composition that concentrates the eye on the centre of the drawing. My main aim was to establish a clear contrast between dark and light. The cat is placed within the centre third of the page. The dark woodland setting reflects a cat's natural nocturnal behaviour; the intense black tone of the border also acts as an eye-stopper and focuses the viewer's eye upon the light centre of the composition (see p.105).

Materials and tools
HB propelling pencil
Black, white and grey soft
 pastels
Tortillon
160gsm (98lb) fine grain
 cartridge paper

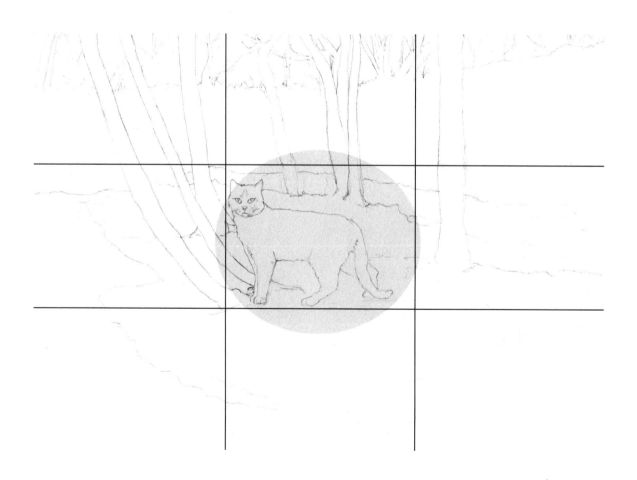

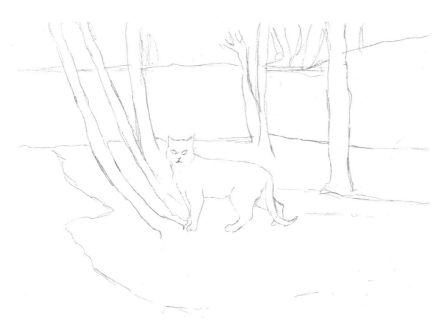

Step 1

I divided the page into thirds so that I could locate the centre and the area within which to draw the focus of my composition – the standing cat. Using an HB propelling pencil, I lightly sketched the form of the cat within a circular perimeter and then began to work on the backdrop. I wanted to create a wooded landscape that would add an eerie quality to the picture without detracting attention from the cat, so when plotting the location of the trees I made sure that their bases were located close to the cat with their trunks radiating upwards and outwards. This draws the eye into the centre of the page and makes the cat the definite focus.

Step 2

I refined the initial simple form of the cat and then added some background detail to the woodland scene.

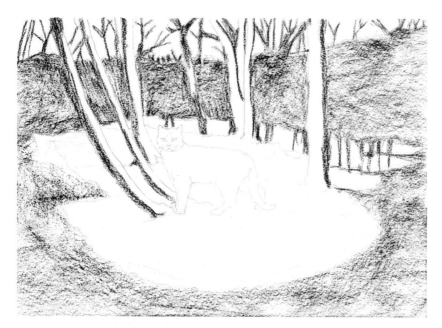

Step 3

I used a black soft pastel to block in the dark areas surrounding the centre foreground. Holding the pastel stick horizontally and rubbing it lightly on to the paper gave a quick, even covering. I wanted to establish the dark areas early so that I could begin to envisage the final tonal effect of the composition.

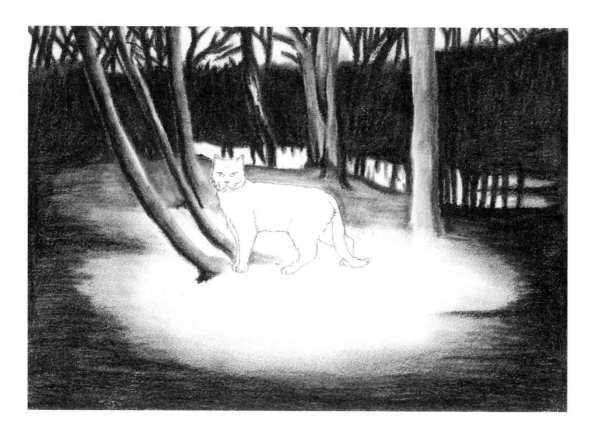

Step 4

I added a second layer of black pastel to the darkest areas, rubbing the stick hard on the paper to achieve an opaque intensity and then blending the pigment into the grain of the paper using a tortillon. Behind the cat there is a pool and the tree trunks are reflected in the mirror-like surface of the water. To portray these reflections I made sure

I maintained a stark tonal contrast between the dark shadows and the light surface of the water. I used a white pastel to add highlight to the inner edges of the tree trunks then, taking a soft grey pastel, I began to gradate the edges of the dark shadows into the pool of light.

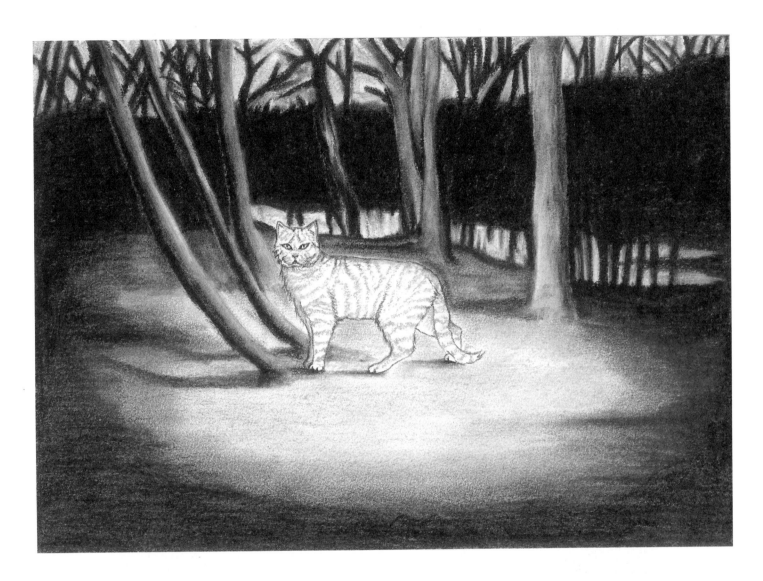

Step 5

Once I had established the final tone of the background I then moved on to adding stripey detail to the body of the cat. Finally, I drew in soft shadows extending from the bases of the tree trunks and beneath the feet of the cat. These shadows bring the whole composition together and make the stark contrast between dark and light work together harmoniously.

Central pyramid composition

This composition follows the same principle as the central type, where the focal point falls within the centre rectangle of the page (see p.102). However, the pyramid arrangement gives you a little more scope for variety in your composition. Instead of just one single primary focus, this structure allows a collection of forms to be depicted, arranged within the pyramid. Overlapping the forms adds cohesion and clarity to your grouping. The pyramid does not have to be mathematically exact, nor does it have to fit entirely into the rectangle.

Mother and puppies

The pyramid composition structure is perfect for depicting the close relationship between the mother dog and her pups. The tall central figure of the adult dog is balanced by the overlapped arrangement of the puppies around her feet to create the pyramid shape. All of the forms within the pyramid overlap each other, tying the family together and making it clear to the viewer that this should be the main focus of attention.

Materials and tools

HB propelling pencil
Willow charcoal sticks
Charcoal pencil
White chalk pencil
Tortillon
160gsm (98lb) fine grain
 cartridge paper

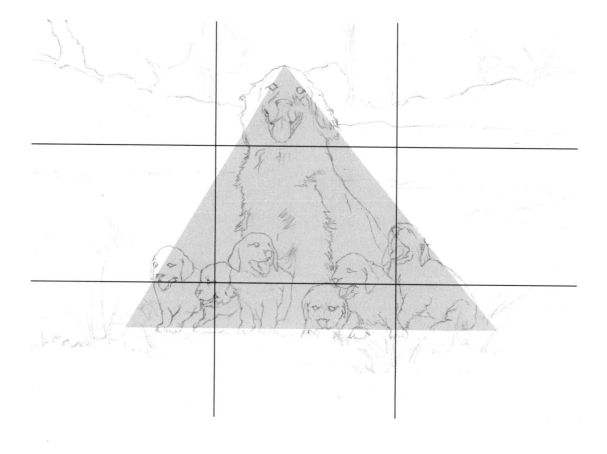

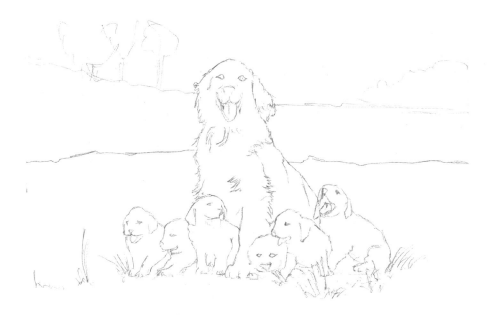

Step 1

After devising an effective thumbnail sketch, I worked up the composition into a larger rough outline sketch with my HB propelling pencil. I used the rule of thirds dividing lines to help me position the pyramid group on the paper. I wanted to balance the bottom of the pyramid, so I drew three puppies on each side of the mother's front leg. This placement adds symmetry. However, absolute symmetry is never very effective in compositions, so I drew the pups in different poses to add variety and interest.

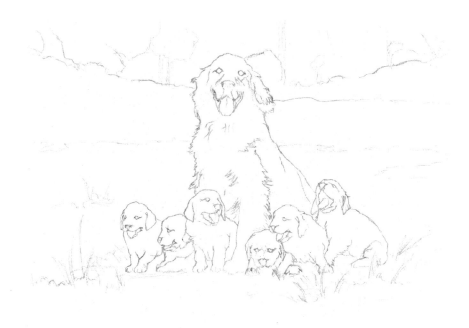

Step 2

Next, I began to refine the outlines of the individual forms and added more definition to the background.

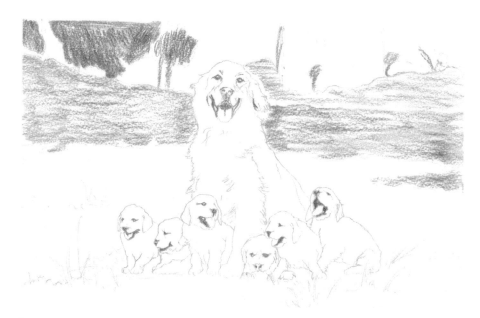

Step 3

Using a stick of willow charcoal, I began to block in the shading of the background landscape. Willow charcoal was the best choice for this stage because it is soft and easy to blend and therefore good for shading in large areas quickly. I then darkened the areas around the mouths and eyes of the dogs.

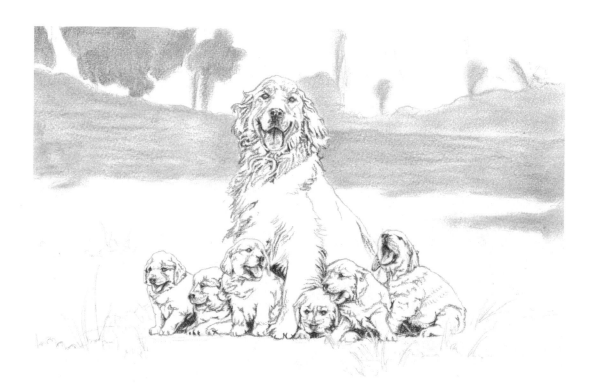

Step 4

I blended the landscape shading using the tip of my finger, creating a subtle, soft effect which throws the central group into focus. I then darkened the faces of the dogs and added detail, using a sharpened charcoal pencil. Next, I darkened the areas beneath the puppies. This shading adds greater cohesion to the composition and the shadow grounds the group solidly within its environment. The charcoal pencil is harder and allowed me to achieve greater detail than the soft willow stick would have provided. I then began to add soft texture to evoke the wavy fur.

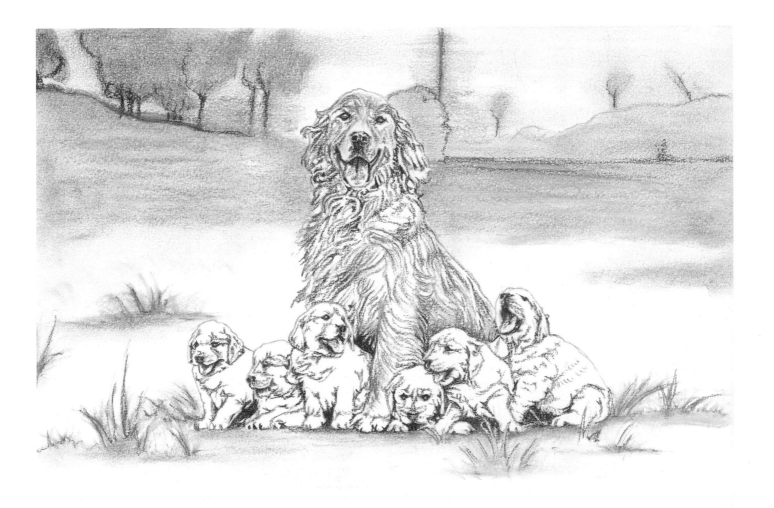

Step 5

I continued adding the fur texture to the body of the mother. I wanted to make her slightly tonally darker than the puppies, so I was very sparing with the texture detail on their bodies in comparison. I used the tortillon to blend and soften the texture slightly and then added a few highlights here and there with the white chalk pencil. Finally, I added some darker tones to the distant landscape and introduced a few clumps of grass in the foreground which act as a border around the central group. These border details help the viewer to focus on the primary subject and prevent the eye from wandering from the centre of the composition.

L-shaped compositions

The L-shaped composition, as you would expect, is structured around an 'L'. The structure can be used in two ways – for tall upright compositions, with the 'L' used vertically, or for pictures organized with a strong horizontal, with the 'L' turned on its side.

When arranged upon this simple underlying structure, the focal elements will guide the eye smoothly around the composition. It is very effective if you position your L-shape to correspond with the intersections made by dividing your page according to the rule of thirds. The eye is naturally drawn into the picture and is carried around the composition through the L-shape.

Boy feeding a rabbit

This composition is structured around a horizontal L-shape. The boy crouches on the ground and reaches out his hand to feed the rabbit. The back of the boy establishes the shortest side of the 'L' and the outstretched hand, together with the form of the rabbit, establishes the long horizontal base of the composition.

> **Materials and tools**
> HB propelling pencil
> Black, grey and white artist's
> oil pastels
> Tortillon
> 160gsm (98lb) fine grain
> cartridge paper

I chose to complete this picture with oil pastel, and so used a paper with a fine grain. I felt that the substantial forms of the boy and the rabbit would look good worked up with the bold creaminess of this medium.

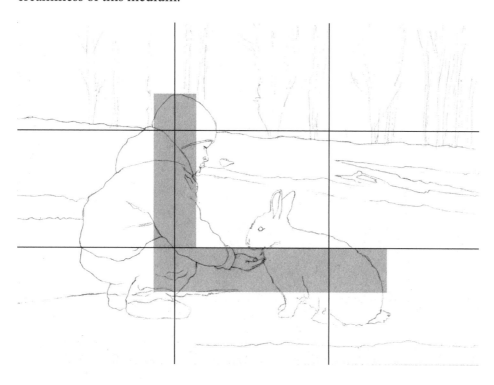

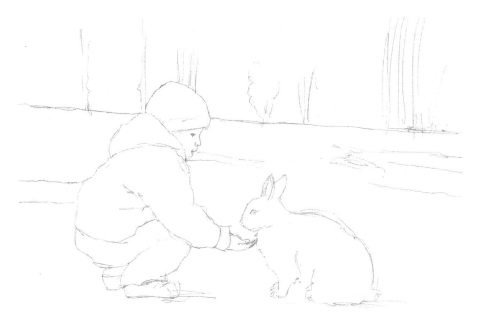

Step 1

I arrived at my compositional layout by making a series of thumbnail sketches. After this process of experimentation, I used the final thumbnail sketch as reference and worked it up into a simple sketch using an HB propelling pencil. I delineated the outlines of the boy and the rabbit and put in some rough lines to show the location of the horizon and trees. Note how the horizon line is placed in line with the top third division.

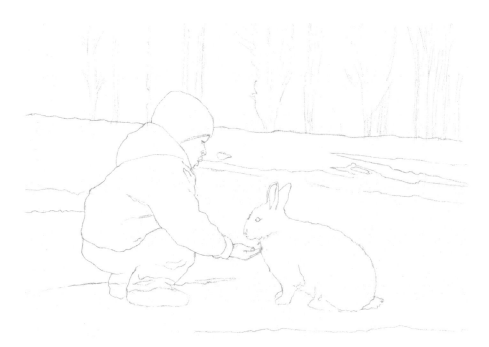

Step 2

I began to define the outline and added some more detail to the horizon, which gave balance to the composition. It's always a good idea to take a step back at this stage to see if you are really comfortable with the effect of your compositional layout. Making a few simple adjustments to the background now is easy and can make all the difference to the overall effect.

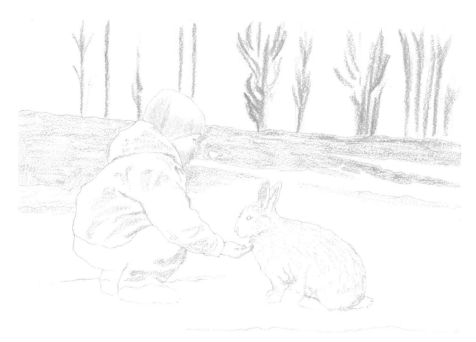

Step 3

Moving on to pastel, I began by using a mid-grey stick to lightly scumble over the surface of the paper and establish an initial mid-tone.

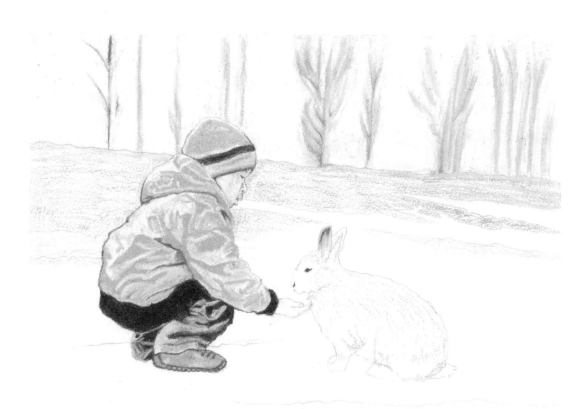

Step 4

Next I concentrated on the crouching boy. I rubbed the grey oil pastel hard onto the surface of the paper to create blocks of dense tone, which start to describe the light and shade produced by the folds of his jacket. I heightened the highlights using a white pastel, then repeated the same technique on the trousers, this time with a black pastel. Taking time over describing the folds of the clothing ultimately helps to evoke the three-dimensional form of the boy. This stage also establishes the light source of the picture, coming from the left-hand side.

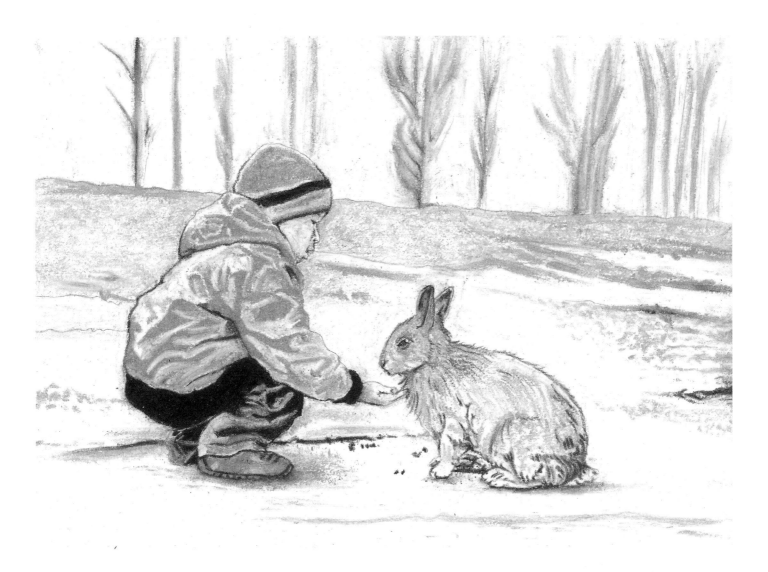

Step 5

I applied the grey pastel to the body of the rabbit, using a stippling motion to suggest the soft texture of the fur. I added shadows beneath the boy and rabbit, which really ties the whole composition together and grounds the pair solidly in their environment. Finally, I added some texture detail to the ground to add interest and variety to the surroundings. I wanted to make the rabbit and boy the darkest-toned elements of the picture, so I kept the background very simple and light. This helps to keep the focus on the 'L' shape and ensures the eye is not distracted by some secondary element of the picture.

Triangular compositions

For creating pictures with multiple points of focus, triangular compositions are very helpful. By locating the centres of interest around the points of the triangle you will be able to guide the viewer's eye around the composition and ensure that all the focal points are taken into account and appreciated in the intended context and order. Once again, it is a good idea to locate your triangle according to the rule of thirds.

Riding in the country

The strong triangular shape underlying this composition is clearly evident in the winding path, a feature that ties the components of the picture together. The eye is drawn into the scene from the top left of the picture, where the path begins in the distance, and is carried through to follow the forward progress of the horses and ultimately down to the foreground where the dog stands gazing into the distance.

Materials and tools
HB propelling pencil
HB light wash watersoluble
 pencil
8B dark wash watersoluble
 pencil
Round watercolour brush,
 size 1
Flat watercolour brush, size 4
300gsm (140lb) cartridge
 paper

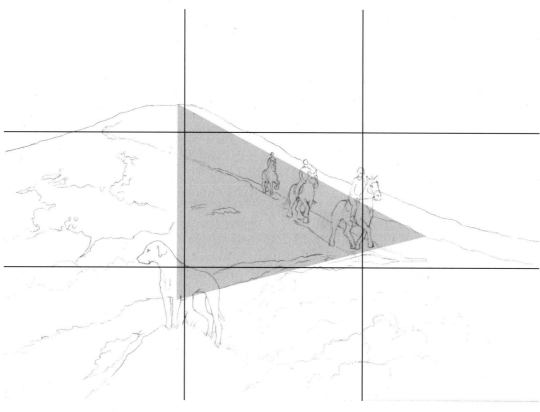

Step 1

I began by dividing the page into thirds so that I could begin to plan the placement of the components of the composition. Using my HB propelling pencil, I started by sketching in the mountain in the distance and began to plan the path. I roughly sketched the forms of the horses, placing the lead horse and rider upon the vertical line so that it draws the eye down into the foreground where the dog stands alert.

Step 2

Once I had established the final location of the elements of the composition I began to refine the outlines of the forms and strengthened the lines of the path.

Step 3

Using the HB watersoluble pencil, I began to lightly shade in the darker tones of the mountainside.

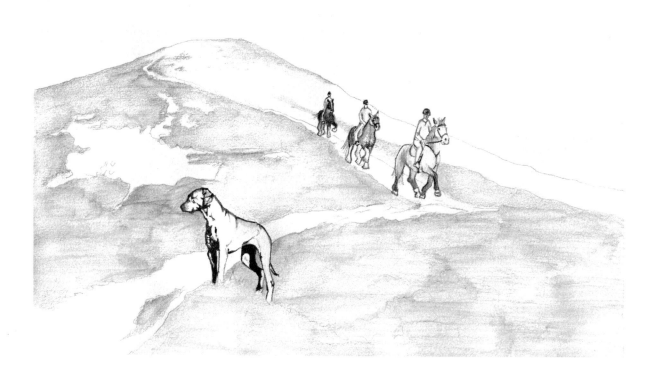

Step 4

I blended this shading with a moistened flat watercolour brush. Then, using the 8B watersoluble pencil, I started to shade in the detail on the three horses and riders and the dog in the foreground.

I wanted to suggest a setting sun and to do this I paid careful attention to the placing of the shadows both on the forms of the horses and dog and upon the mountain background.

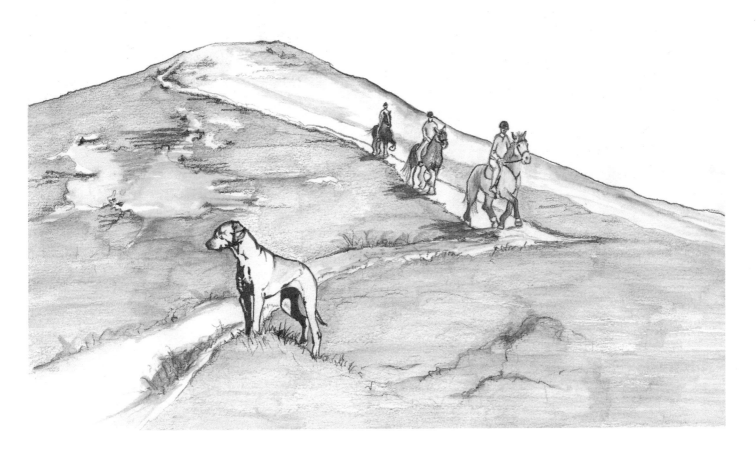

Step 5

Taking a moistened round watercolour brush, I began to blend the shading. I then added some more shading and texture details to the mountainside. However, I wanted the dog and the horses to remain the primary focus of the composition, so I left the background very subtle and simple.

Beach scene

Dogs love a walk at the seaside, so I thought the beach would be a perfect backdrop for this composition. The relationship between a dog and its owner is usually very close and I wanted to convey this in my picture. The triangular composition was perfect to tie the figures of the dog and boy together. The intense gaze of the dog follows a diagonal path towards the hand holding the ball, while the boy looks back down at the dog, emphasizing this mutual connection. The viewer anticipates the next action of the scene, imagining the ball being thrown and the dog chasing enthusiastically after it.

Materials and tools
HB propelling pencil
Ivory Black and Payne's Grey
 watercolour paints
Large flat watercolour brush –
 I used a size 1
 (1.5cm/⅝in)
Round watercolour brush,
 size 1
425gsm (200lb) Not
 watercolour paper

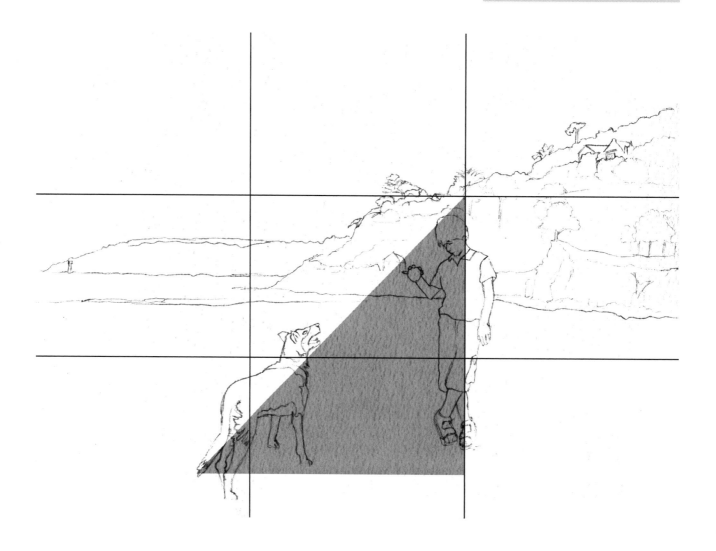

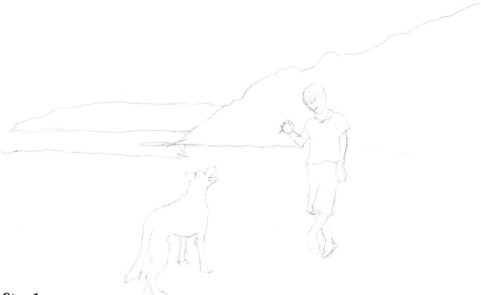

Step 1

I divided the page into thirds and started to plan my composition by locating the key elements – the boy and the dog – around a centrally positioned triangle. Using an HB propelling pencil, I sketched in their forms, making sure that their position accentuated their connection – the gaze of the dog is directly linked to the position of the ball in the boy's hand. I then began to sketch in the background, making sure the horizon line in the distance corresponded to the top horizontal third line. I sketched in two cliffs on the right-hand side so that they continued the strong diagonal established by the relationship between the boy and the dog.

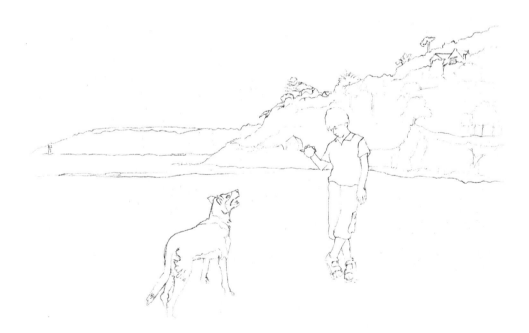

Step 2

I refined the outline of the figures and began to add some rough linear detail to the cliff in the background.

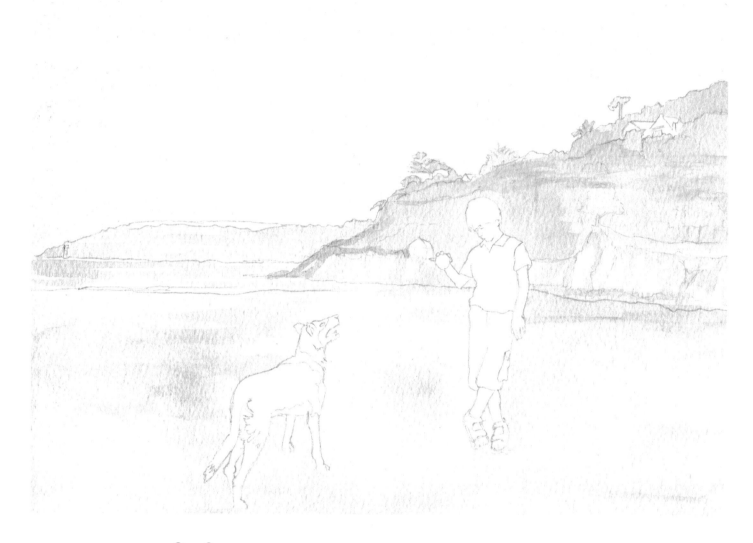

Step 3

Next I mixed a light wash of Payne's Grey and applied it to the
background, using the flat brush. Laying in this initial light tone
establishes a good overall tone that can be darkened gradually.
Always work slowly from light to dark when using watercolours.
Highlights are provided by exposed clean paper, so make sure you
keep these areas completely free of paint.

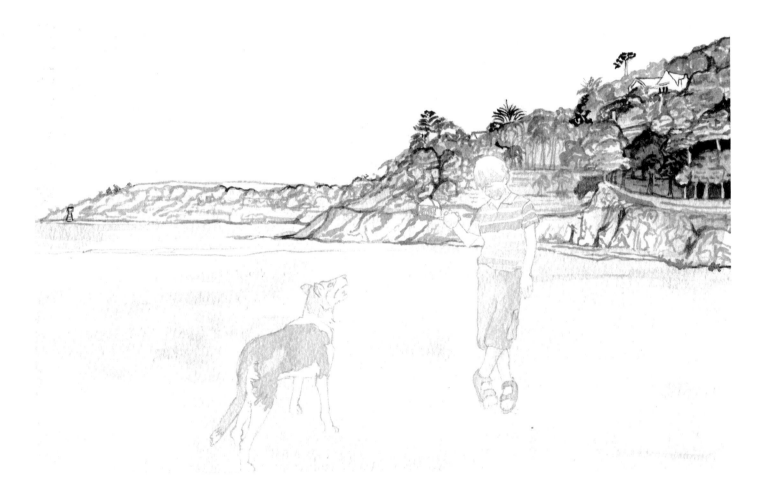

Step 4

Using the round brush, I mixed a strong solution of black and started
to add darker tones and details to the area of cliff behind the boy.
The process was relatively quick and sketchy and I didn't attempt to
describe perfect detail as I think a loose and free style is preferable
for watercolour sketches. I then began to darken the tone of the
boy and dog using a dilute solution of Payne's grey. I also added
some stripes to the T-shirt of the boy, which began to add a three-
dimensional feel to the form.

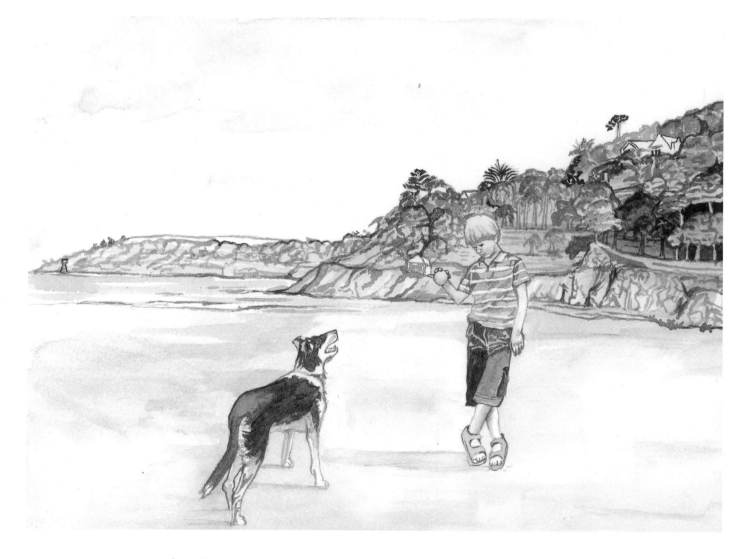

Step 5

I darkened the shorts of the boy and the coat of the dog, establishing the pair as the focal points in the composition. I added light shadows upon the sand beneath the feet of the two figures; this last detail brings the whole composition together. Finally, I added a very subtle wash to the sky to give the appearance of a clear evening sunset.

Kitten playing with a ball of wool

The ball of wool unifies the protagonists of this picture; the kitten playfully bats the ball on the ground while the girl holds the yarn in her hands. The wool establishes the diagonal side of the triangle and the girl stands at a right angle with the decking floor. The plant pots and the wooden fence help to border the composition and stop the eye from wandering off the edge of the picture.

Materials and tools

HB propelling pencil
8B pencil
Eraser
300gsm (140lb) cartridge
 paper

As this composition has a lot of secondary supporting elements surrounding the primary subject, I wanted to keep the style of the finished piece very clear and simple so as not to overcomplicate the composition. I therefore chose to complete this picture using just pencil.

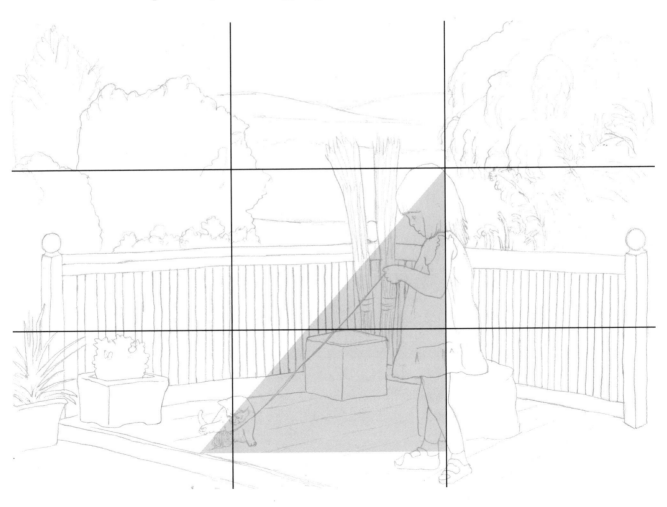

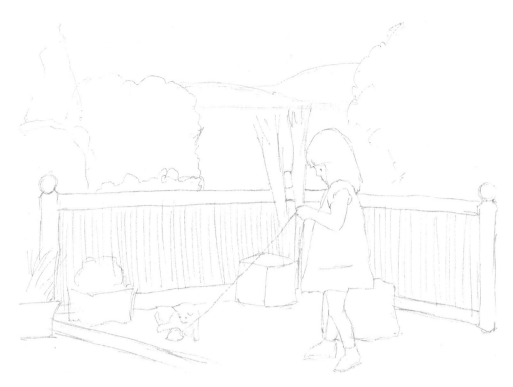

Step 1

I began by dividing the page into thirds and sketched in the girl and the kitten in a triangular composition, using an HB propelling pencil. The triangular layout is further accentuated by the diagonal created by the wool extending from the girl's hands down to the kitten playing on the floor. I wanted to maintain the focus of the eye on the girl and kitten, so I added the fence and decking to the background to act as a perimeter that keeps the eye from wandering.

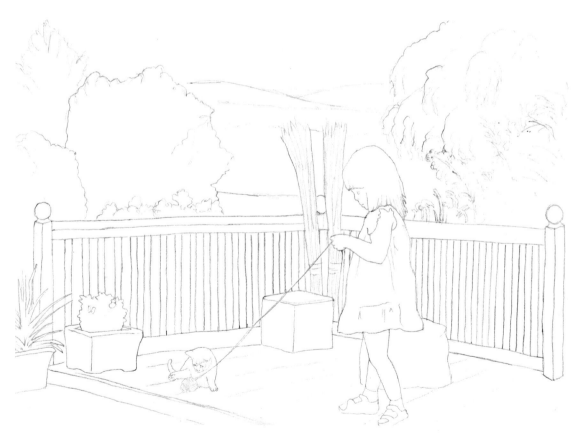

Step 2

Once I had established the general forms within the composition I began to strengthen the structural details of the fence.

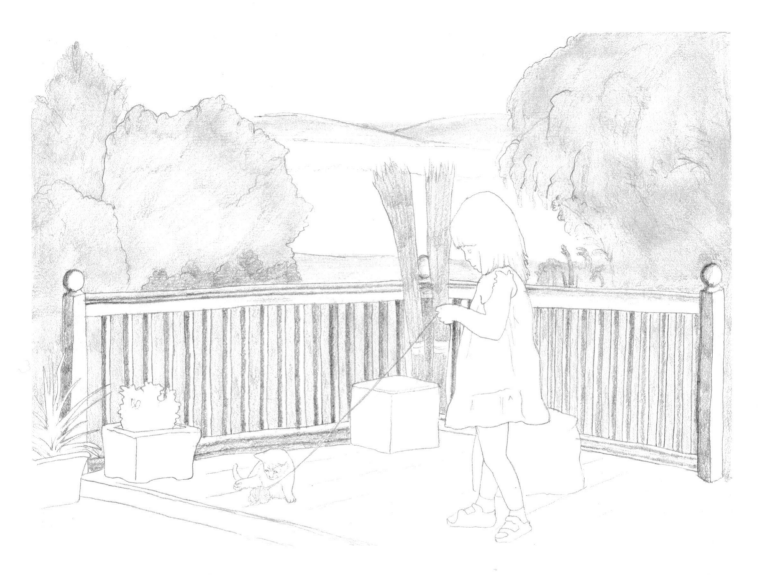

Step 3

Still using the HB pencil, I shaded in the trees and foliage in the background and the wooden uprights of the fence. I then blended this shading to a smooth finish, using the tips of my fingers.

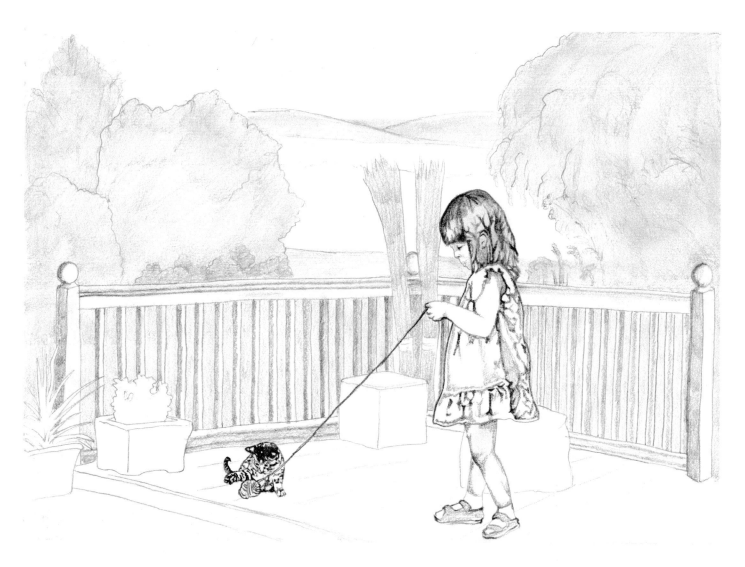

Step 4

Next I started to shade in the detail of the little girl and kitten, using the 8B pencil to establish the darkest tones of the forms. I started with the top of the girl's head and down into her hair to produce a sleek, glossy appearance; I then moved on to explain the fabric folds of the dress. I darkened the string linking the girl and kitten, which further accentuates their connection. Then I began to work up the fur markings of the kitten.

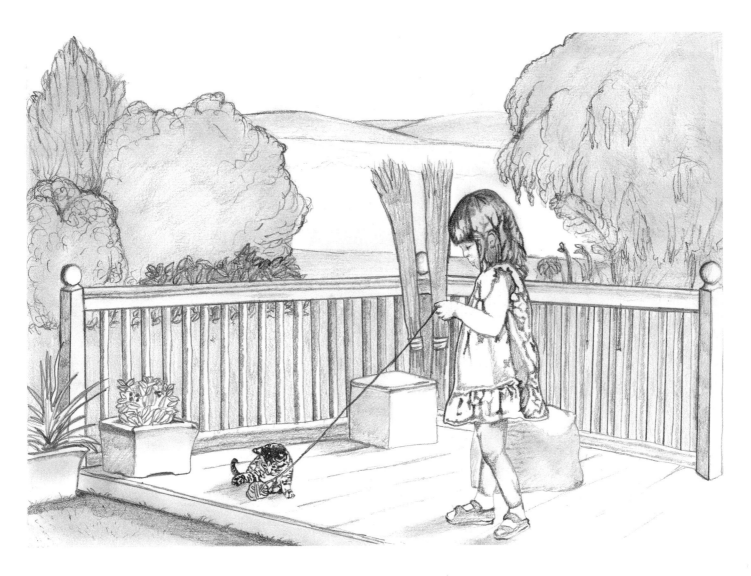

Step 5

Finally, I added shade and detail to the secondary supporting features, which brought cohesion to the composition. I added a little texture detail over the base tone of the trees but I didn't want to overcomplicate the scene, so I left this part of the background very simple.

Index